ARTFUL ADVENTURES
IN MIXED MEDIA

ART AND TECHNIQUES INSPIRED BY
OBSERVATION AND EXPERIENCE

NATHALIE KALBACH

NORTH LIGHT BOOKS
CINCINNATI, OHIO
www.artistsnetwork.com

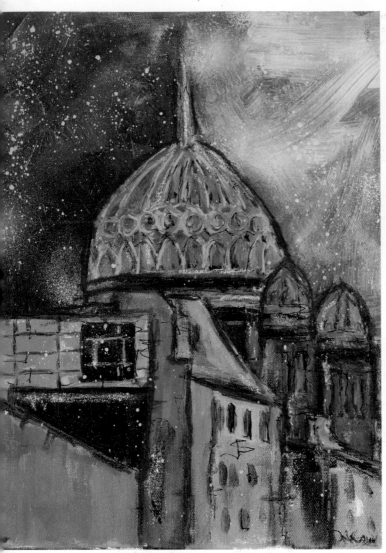
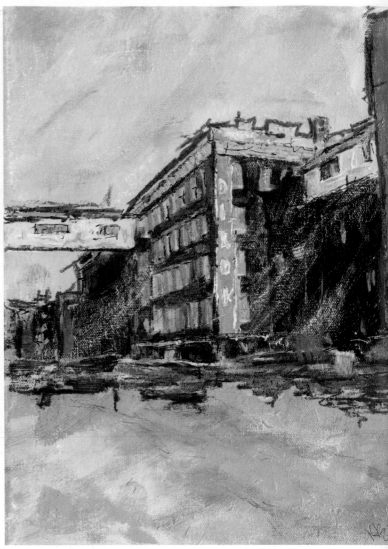

CONTENTS

ACKNOWLEDGMENTS

This book would not have been possible without the help and encouragement of some very special people.

I would like to thank the wonderful crew at F+W who made this book a reality, especially my editors, Noel Rivera and Tonia Jenny, and amazing photographer Christine Polomsky.

Thank you to the contributing artists for your stunning artwork. I am very grateful to have you as friends and appreciate your generosity and talent.

A special thank you to Adam Cvijanovic, the Robert Rauschenberg Foundation, the Whitney Museum and Mark Bradford. Without your help I would not have been able to include images of the artwork that inspires me.

A heartfelt thank you to my ever-so-amazing and encouraging husband, Jim, and my family, to my pal Judi Kauffman for her eagle eye and ready ear during the writing process, to Kim Bricker and the Creative Squad for helping me to stay sane and keep up with my other work, and to my friends the Beekman-Lane-Gang, my Dixon-Friends and Die Fischköppe for being there for me and making me laugh out loud whenever I was stuck.

But most of all, thank you to each and every one of my students, with an extra shout out to Denise for the nudge to get this book on its way. You are all a constant source of inspiration and support. You gave me this book!

 ## DEDICATION

To Jim, my husband and biggest cheerer-upper! You amaze me.

—Love, Nat

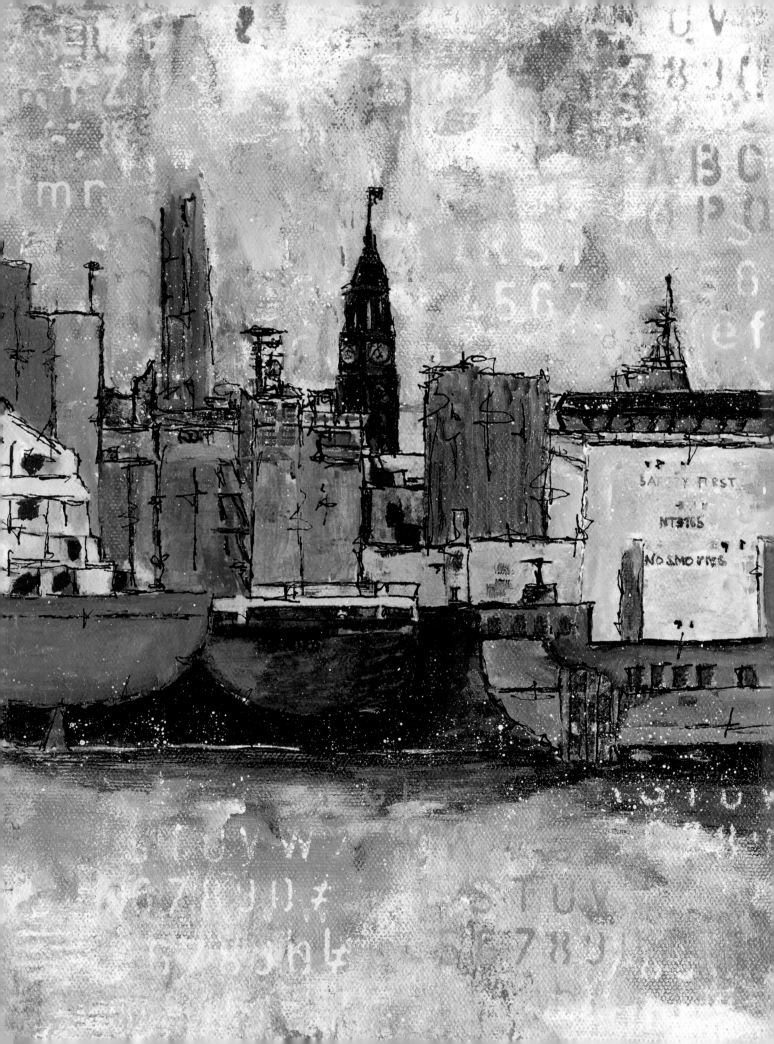

INTRODUCTION

We all know the moment when we hit a creative block in a project. Many times when this happens to me, I leave my studio and go for a walk through the neighborhood to get a change of scenery, and I hope I'll return with my mind refreshed and ready to let inspiration strike.

Frequently, during those walks, what I need emerges. As I wander, something will catch my eye: a manhole cover with a grid-like design, a door with unusual hardware, or graffiti on a wall. I take pictures with my phone's camera, and when I look through the photos later, the manhole cover—or whatever—catches my interest once again.

I print out the photo and study the pattern; I trace it and let it sit on my desk. The next day, when adding a layer to the canvas that has me stumped, I incorporate elements of the pattern from the manhole into my painting—not by copying it, but by transforming it into something different. Combined with other sources of inspiration, I suddenly have something new that appeals to me and feels personal. I'm excited and elated about my idea and my work.

Moments like this happen over and over again, and it's fascinating that something as simple as a walk can spark ideas for your artwork. So how does it work?

By combining skill and inspiration, we unleash hidden creativity and transform our artwork into something unique. While skills are the tools used to create, inspiration is the creative nutrition for our artwork. Skill is not a substitute for inspiration, but mastering our skills can help us when inspiration strikes.

But where do new ideas, the essence for inspiration, come from? For me, it all starts with observation, followed by the collection of ideas, then the transformation into something new: the artwork. I collect, note, record, sketch and write what I experience and see. Then I revisit and review my notes, often by turning them into blog posts, like the "Stroll Through the Hood" series. When I go to museums, I create "Art Stroll" posts, or after I travel, I write "Inspired By" posts.

These are personal ways of vetting the ideas these experiences can spark. While I write, I think about how to translate my observations into my artwork, oftentimes by leaving my comfort zone, and then, last but not least and most importantly, I make art!

"THE FACULTY OF CREATING IS NEVER GIVEN TO US ALL BY ITSELF. IT ALWAYS GOES HAND IN HAND WITH THE GIFT OF OBSERVATION."

—IGOR STRAVINSKY

HAMBURG HARBOUR

Nathalie Kalbach
Acrylic paint, acrylic ink, and spray paint on canvas
12" × 9" (30cm × 23cm)

Inspired by the daily changing scenery of the Hamburg Harbor, located in the middle of the city.

"DON'T LOAF AND INVITE INSPIRATION; LIGHT OUT AFTER IT WITH A CLUB."

—JACK LONDON

ARTFUL ADVENTURES

This book strives to help you prepare and seek inspiration and to incorporate found inspiration into your own personal artwork.

To break it down, here are the five things that I believe are most relevant for inspiration in art:

1. Everyone can be creative.

There is this myth of the genius artist who gets inspiration for artwork in a surprising moment like a lightning bolt, but rarely is that the case. Most artists are ordinary people who aren't divinely struck and inspired out of nowhere to create art. They work at it. New creative ideas stem from something existing. They come to life when artists spot other ideas, observe the world around them and are stimulated by something new, whether in a positive or negative way. Be prepared to observe.

2. Embrace what you observe and how you feel.

It all starts with being open-minded and recognizing that anything can be inspirational, that everything can spark new ideas. Whenever you stroll through your neighborhood, travel, are out in nature, visit a museum, watch a movie, read a book, or talk to people, you are opening yourself to endless possibilities. Inspiration is all around us, you have to be ready for it and collect it—loads of it. You need to make this a daily habit.

3. Love it or list it: Find what appeals or doesn't appeal to you.

Listen actively to your own thoughts and responses whenever you observe something. Take note of it. When you stay alert and pay attention to how you react to your observations, you open yourself to new ideas. Revisit your notes and tend to them like little seeds that could flower into something stunning. Connect the dots and let your mind wander until unrelated ideas form a new and interesting one that is worth going after.

4. Imperfection takes bravery.

Translating inspiration into artwork is about reacting to an emotional response. Don't think about what it *is*, but rather about what it *could be*; it rarely looks like what you imagined. Don't cheat yourself out of the liberating process of art-making by limiting yourself to perfection. You must create art if you want to thrive in your development: good art, bad art, ugly art or disastrous art. Learn through your failures. Develop an imagination of the possible with each layer you create in your artwork, and stay open to being like the blue jay on my terrace that picks up sparkly objects and rearranges what's in my planters. I like to think of it this way: Creating art is an argument you're attempting to work out rather than battle. Be brave and work it out!

5. If it feels good—do it!

Don't think about how others might receive your artwork. Make art that *you* care about and that feels good for *you*. And, again, make a lot of if it. Just do it!

LA BOCA

Nathalie Kalbach
Acrylic paint, acrylic ink, marker, charcoal, and collage elements on canvas
12" × 9" (30cm × 23cm)

Inspired by the colorful neighborhood of La Boca in Buenos Aires, Argentina.

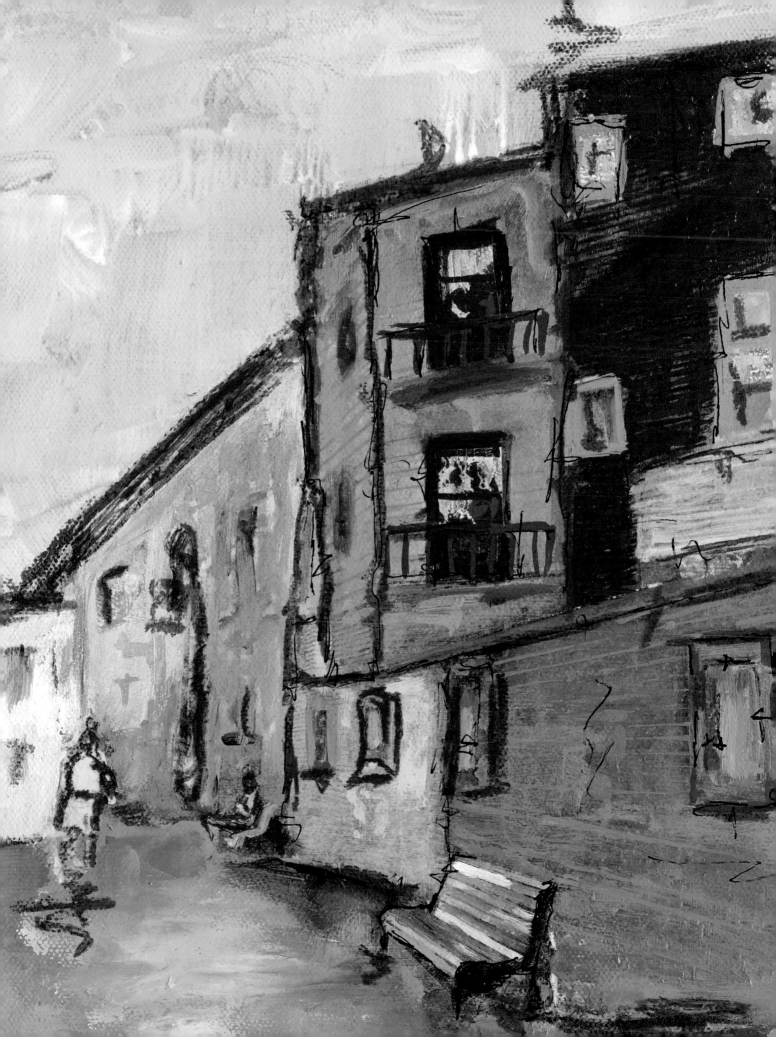

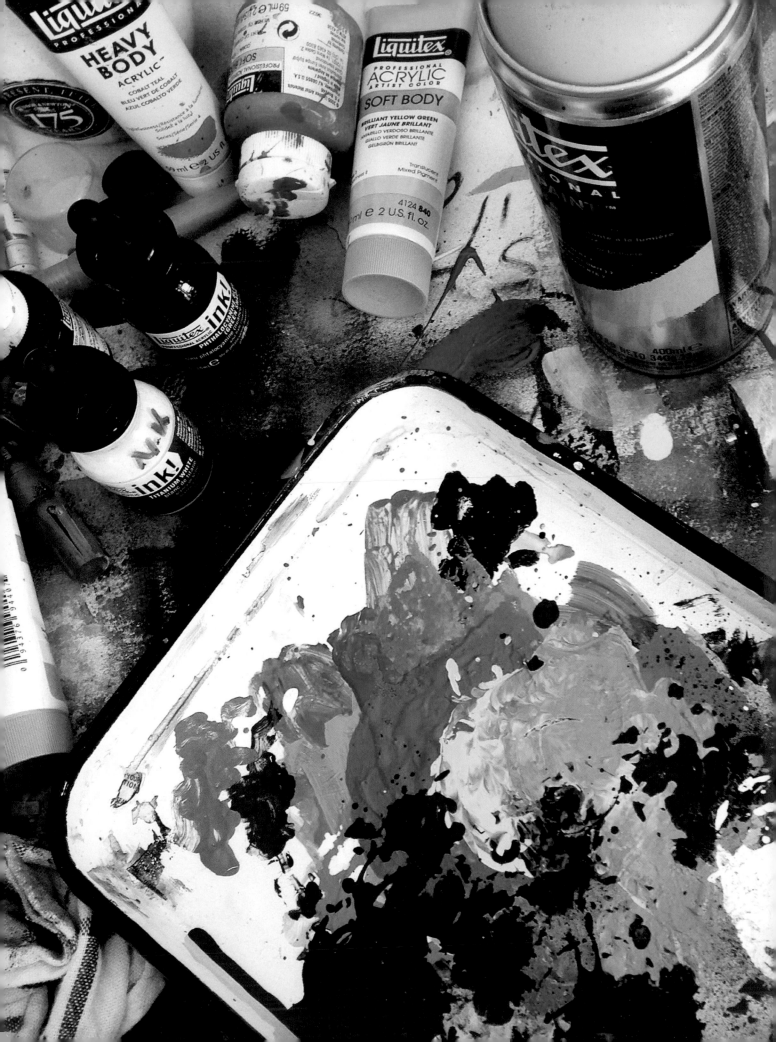

1

GATHERING THE BASIC SUPPLIES

You can get by with a surprisingly limited number of supplies to create artwork. The materials are not going to make or break your artwork; it's the story behind it and the inspiration that led to it that are most critical. For that reason, my basic supply list includes items to gather and collect as inspiration as well as an art supply list for creating the actual artwork.

Versatile supplies with multiple uses fascinate me. They bring out the researcher in me, the experimenter, the crazy girl, the one who wants to know, to play, to create and to inspire others.

The wonderful side effect of this is that whenever I go into my collect-research-and-experiment mode, the supplies themselves often provide the inspiration.

Without further ado, please meet some of my favorite basic supplies.

"YOU BEGIN WITH THE POSSIBILITIES OF THE MATERIAL."

—ROBERT RAUSCHENBERG

Nathalie's messy workspace

SUPPLIES FOR COLLECTING INSPIRATION

Inspiration begins before you start creating art. Art is everywhere, so be prepared to capture your inspiration and experiences. Integrate these tools into your daily routine.

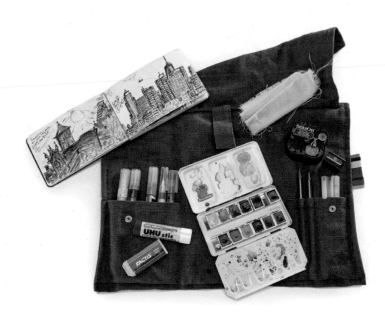

Small Notebook

I carry a notebook with me wherever I go. I can write down anything noteworthy that I observe in my hunt for things to translate into my artwork. My favorite notebook is a Midori Traveler's Notebook. It's small in size and has a sturdy leather cover with an elastic band in the center that holds inserted premade notebooks. I use it not only as a notebook but also as a travel journal. One of the Midori Traveler's Notebook inserts is a clear zippered pocket into which I stuff paper ephemera I have collected.

Art-on-the-Go Kit

I carry a small bag with me that contains a sketchbook and other basic supplies I use to make visual records of whatever inspires me. I will talk about the art-on-the-go kit and its content in detail in chapter 4.

Camera Phone

My smartphone is a constant help and rarely do I use it for its original intended purpose of making and receiving phone calls. I use the camera daily to photograph my artwork-in-progress and anything that inspires me. I download my phone photos onto my computer at home and sort them in folders divided by source of inspiration: street art, city, nature, patterns, etc. In addition to still shots, I also use my phone to record videos so I can remember sounds and movements that inspire me.

Apps

There are certain apps on my phone that I use constantly, too:

➤ **Notes:** Digital note-taking for those times when a notebook and pen isn't the right choice, or when you want to be able to send notes via e-mail or text message.

➤ **Citymapper:** I walk a lot and constantly take public transportation, at home as well as when I travel. Citymapper and Google Maps have become lifesavers for me.

➤ **Museum apps:** Many museums have their own apps that can be used through their free Wi-Fi system in the museum to learn about their collection and special exhibitions. Oftentimes they provide self-guided audio tours, and they're a wonderful way to explore. The Museum of Modern Art app even lets you create your own photographic collection of artwork and encourages doing so in the galleries where photography is allowed.

➤ **Pinterest:** Pinterest is a web-based photo-sharing platform on which registered users can create digital pin and mood boards and share them with others. It's a great way to sort collections for inspiration (by theme, artist, museum, etc.).

ART SUPPLIES

Below is a list of basic tools and materials I use throughout the book, and which you will use well beyond. I will delve into each of them in upcoming chapters.

● PAINT SUPPLIES AND MEDIUMS

Acrylic Gels and Primers
I used a variety of acrylic gels and primers in my samples throughout the book: Liquitex Gel Medium, Natural Sand, and Glass Beads, as well as white, black and clear gesso. Their properties will be discussed further in chapter 3.

Acrylic Inks
Acrylic inks are fluid acrylic-based paints with extra-fine pigments and are permanent when dry. They give a watercolor-like effect and can be used in many different ways in your mixed-media projects, including painting, staining raw canvas, fabric painting and photo tinting, to name just a few.

Acrylic Paints
Acrylic paints are my favorite art medium because of their versatility. I love that they come in different viscosities (thin, soft, fluid, heavy). They dry quickly, are permanent, can be used with different mediums and are easy to clean up. For the projects in this book, I used mostly artist-grade soft body or fluid acrylic paints.

Water-Soluble Wax Bars
Derwent Artbars and Caran d'Ache Neocolor II are wax-based pigmented sticks that are water-soluble. They are creamy in consistency; the colors are very intense. Both can be used for paint applications or mark-making and texture.

SURFACES

Art Journal

Art journaling has become an art form in and of itself for me. An art journal is also a great starting point to try out new supplies and techniques. I talk about various art journal options and ways to use them in chapter 6.

Canvas Boards

For many of the samples throughout the book, I used purchased canvas boards measuring 6" × 6" (15cm × 15cm) or 8" × 8" (20cm × 20cm). Canvas boards are an economical substitute to stretched canvases. Cotton duck is mounted to a thin board, which usually comes pre-primed with gesso.

Corrugated Cardboard

I really like painting on corrugated cardboard. I cut pieces from shipping boxes, then seal them with gel medium or prime them with gesso. The rough texture and Kraft brown color provide interest.

Hemptique Hemp Paper

Hemptique Handmade Hemp Paper is made of hemp, linen and cotton. It has a wonderful texture and is pliable like fabric. It can be used for watercolor applications, writing and drawing, pastel and charcoal, and inkjet printing.

Stretched Canvas

Stretched canvas is cotton or linen fabric that has been primed and stretched around a wooden frame.

PENS AND MARKERS

Acrylic Marker

Acrylic markers are some of the most-used writing and drawing tools in my mixed media work. Liquitex Professional Paint Markers are my go-to markers for their pump system and the different sizes and nibs available. They're also a great way to travel with acrylic paint.

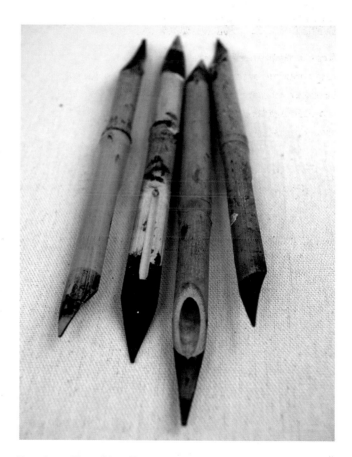

Bamboo Sketching Pen

These pens are carved from bamboo shafts and can be used with liquid ink. They're great as writing tools or for easy drawing applications.

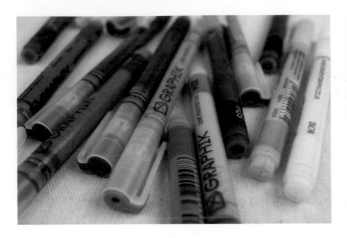

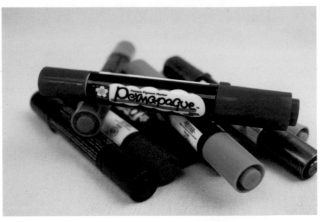

Derwent Graphik Line Painters

These are my favorite art journaling and sketching pens because they work beautifully over nontextured, acrylic-painted surfaces. They're fine-line paint pens filled with permanent, opaque, water-based paints. They can also be used for interesting wet effects before they dry.

Pencils

In addition to the standard no. 2 (HB) pencil, I love to use the softer 4B pencil for mark-making into wet and/or dried paint.

Sakura Permapaque Opaque Pigment Markers

These odorless opaque pigment markers are permanent and have a chisel tip for broad marks at one end and a bullet nib for fine lines at the other end. They're great markers to use on surfaces like acetate, metal and glass (but they're not permanent without sealer on nonporous surfaces).

Xylene Blender Pen

For the transfer technique used in this book, I have found the Chartpak AD Marker Colorless Blender pen works best. Only blender pens with xylene will work for this technique because they're solvent based. When working with these pens, you *must* follow the manufacturer's instructions: Work in a well-ventilated area and be careful that the solution does not come in contact with your skin or eyes.

ACRYLIC PAINT BRUSHES

Paintbrushes are one of my magic tools for painting, applying mediums and making marks. They come in many shapes and sizes. Here are the eight acrylic paintbrushes I pick up again and again for my artwork, and the sizes I prefer:

Flat, Size 6

Flat brushes have a square end and medium-long bristles. They hold a lot of paint. I use them for bold, even strokes, to fill in large areas and backgrounds, and for impasto. The side edges of a flat brush can be used to paint fine lines and straight-edged lines.

Filbert, Sizes 4 and 12

Filbert brushes have a flat and cat-tongued form with medium-long bristles. When used on the side, they create thin lines; when used flat, they create broad brushstrokes. I use them to blend areas together or create soft, rounded edges.

Round, Size 6

Round brushes have a rounded tip and are perfect for detail work. They work best with thinner-bodied paints for filling in small areas and are great for blending.

Paddle Brush, 3" (8cm)

My favorite paddle brush has a long-bristled flat tip and is the perfect tool for big surfaces and even application of paint and mediums, as well as for washes.

Fan Brush, Size 6

Fan brushes have a spread-bristled flat tip. They're wonderful for blending and feathering, as well as for many textural painting effects. I use them for collaging because the fanned-out bristles allow me to push adhesive or mediums underneath the edges of collage material to make sure it is spread evenly but thinly.

Bright, Sizes 2 and 12

Bright brushes are short-bristled and flat with inward curving edges. I use them mostly on canvases with heavy color, as they are good for controlled strokes. The flat part can be used for thick lines, while the round sides can be used for thin line applications.

OTHER MIXED MEDIA SUPPLIES

Clear Transparency Sheets

Grafix Dura-Lar Sheets are my go-to transparency sheets for printing and other wet media. They come in different sizes and thicknesses. I prefer the 8½" × 11" (22cm × 28cm) size and always use the .005" (1mm) thickness for cutting stencils and masks.

Artist Tape

Assorted tapes are a must. I keep tapes on hand that are low-tack, double-sided, temporary and permanent.

Sandpaper

I keep sanding blocks and sandpaper sheets on hand in a variety of grits ranging from fine to coarse.

Collage Material

This can be direct mail, maps, tissue paper, fabric scraps, ribbon and buttons. See chapter 5 for more about collage materials.

Craft Knife

I use a PenBlade safety scalpel with a retractable blade. Keep replacement blades on hand. Mixed-media materials wear blades out more quickly than simply cutting paper.

Discarded Key Card or Gift Card

Old hotel key cards or gift cards with no remaining value can be used as palette knives. They can also be cut and used as tools to create decorative marks or textures.

Palette Knife

Palette knives are not only great tools to scoop out or mix paints, but also to apply paint and create texture.

Scissors

Small Teflon-covered scissors work best.

Monoprinting Plate and Rubber Brayer

The monoprinting plate can be a glass, acrylic or gel plate. My favorite monoprinting plate is the Gelli Arts Gel Plate. I talk in detail about monoprinting and the supplies needed in chapter 4.

Awl or Paper-Piercing Tool

Pick an awl or paper-piercing tool that feels comfortable in your hand. They are available with short, round handles as well as long, thin ones.

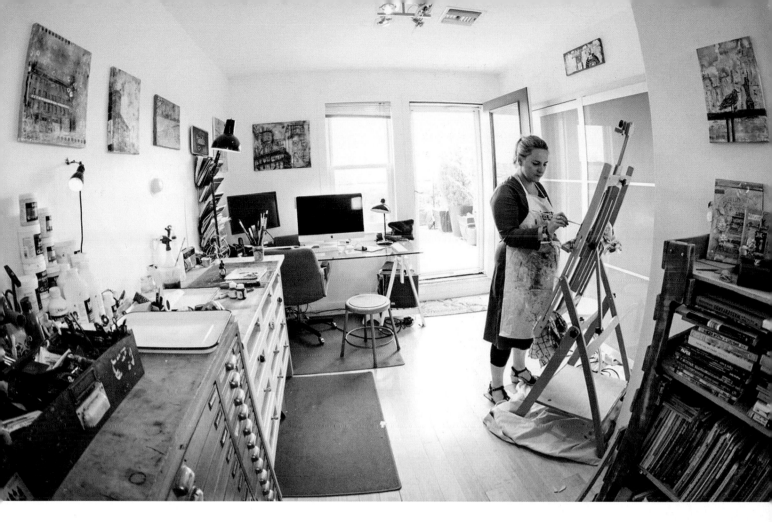

Nathalie in her studio

Embroidery Thread

Embroidery thread comes in hundreds of colors. It's available in cotton, silk and wool, and is often multi-stranded. I choose my palette the same way I choose paints: What I like best finds its way into my studio.

Tapestry Needle

Tapestry needles have a long eye and are easy to thread with multiple strands of embroidery floss. The point is blunt, which means that holes need to be pre-pierced with an awl or piercing tool for most mixed-media projects.

Deli Paper, Waxed Paper, Parchment Paper

Sold by the sheet and/or roll, translucent deli and waxed paper, as well as the slightly heavier parchment paper, have many uses. I keep all three in my studio.

Printer or Copier

Some of the techniques in this book require access to a printer or copy machine. Depending on the technique, a laser or inkjet print or a photocopy may be required.

Printing Paper

Matte or gloss photo paper and lightweight copier or computer printing paper can be used in mixed media. What I use for each project is described in the instructions.

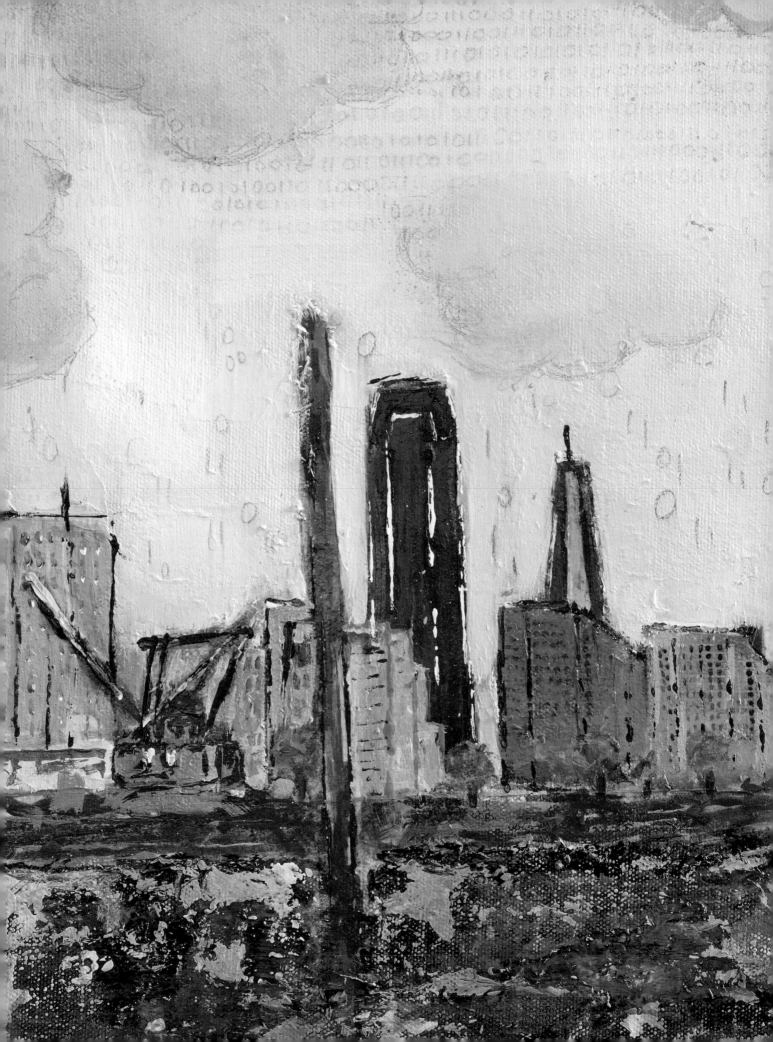

2

DRAWING INSPIRATION FROM CITIES AND TOWN CENTERS

Cities and town centers represent a concentration of human energy. They draw us in, attracting us with all they have to offer.

BINARY FUNCTION

Nathalie Kalbach
Acrylic on paint, acrylic marker, spray paint and collage elements on canvas
12" × 12" (31cm × 31cm)

Inspired by Liberty Harbor Marina and the view of Manhattan.

EXPLORING URBAN TREASURES

Cities and town centers have always been fascinating to me, and I draw most of my inspiration for my artwork from urban surroundings. I was born in Germany in the city of Düsseldorf, and I lived there until I was twelve years old. Our apartment was on a side street with lots of trees, right across from a little park with a playground, and I clearly remember playing there with my friends. When I was in the fourth grade, we had an especially interesting lesson about the history of the city, a vivid memory for me to this day.

Düsseldorf was founded in the thirteenth century, then occupied and under French influence on and off during the eighteenth century. The street names and architecture still told some of these stories, and I remember walking around the neighborhood with my friend Katja to find the traces of a history long gone. We would look at the façades of buildings built at the turn of the twentieth century, as well as newer ones built after World War II, and we'd fantasize about the lives and stories of people who lived there before our time. It became a game akin to a scavenger hunt to point out the most opulent balconies or doors and find interesting little details. We delighted in these things and considered them urban treasures, knowing that others might not notice or find such details as inspiring as we did (and as I still do).

When I was a teenager, we moved to a small town and even though I loved living there, I always knew deep down in my heart that as soon as I had a chance, I would move back to a big city. I missed the energy and bustle, the noise, the fast pace.

When I was twenty, I moved to Hamburg, the second-biggest city in Germany. Yet again, I found myself walking around, awestruck as I looked at the buildings, street art, parks and more, always on the hunt for urban treasures that would make the city special for me. Those walks instilled in me a great love for my newfound home. Later, after quitting my career as a paralegal, when I found my true profession as an artist, I realized that a lot of the inspiration I craved and needed was right in front of me, surrounding me, offered as a gift from the city itself. Hamburg offered a unique and never-ending supply of sights and sounds.

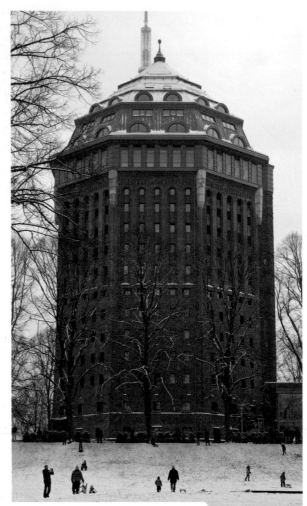

Water tower in Hamburg, Germany

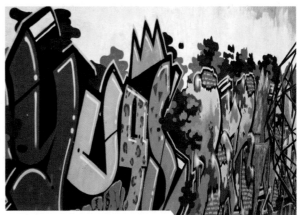

Graffiti in Hamburg, Germany

A couple of years ago I made an even bigger leap, crossing the pond and moving to the United States. Now I live in Jersey City, where a fifteen-minute train ride takes me across the Hudson River into Manhattan—New York, New York.

I have explored my new city with great curiosity, always on the lookout for urban treasures—sights, photos, found objects, anything and everything that can work its way into my art. Being so open has also made my new city feel like home. I capture my walks (or "Strolls Through the 'Hood" as I call them) with photos. I find it interesting and compelling to make note of differences between European and North American fire escapes, mailboxes, architecture; even the power and cable lines are linear in a different way. I have included many of these little details, along with broader views of the city, in my artwork, and I have incorporated them into my stencil and stamp designs as well.

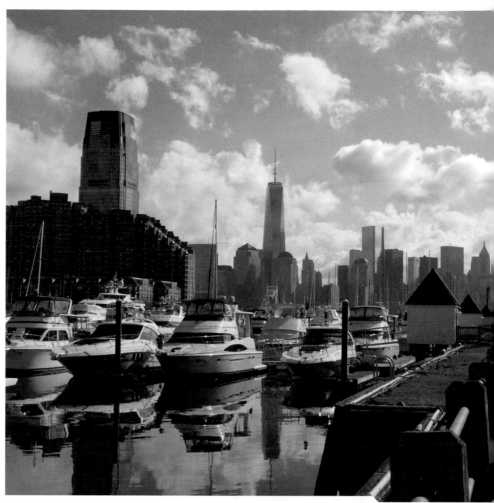

View from Liberty State Park in Jersey City, New Jersey to Manhattan, New York

To step back for a moment and sum things up, I was raised in a city, moved to a small town I knew like the palm of my hand, then moved to a big city, and still another, and with each move I discovered that all of the things around me were exactly what I needed for creative inspiration. That's why this chapter on cities and town centers is devoted to using where we live and where we travel to create art.

It sometimes seems easier to find inspiration when traveling to cities other than where we live, whether they're in our own country or on foreign soil. We notice things that are different; we're more likely to document what we see with a camera, or in a sketchbook or journal. In our own city, the key is to open our eyes in the same way, to see what a visitor might find unique and inspiring, essentially playing tourist in our own town to trigger a visit from the muse.

You might not live close to a city like Hamburg, Jersey City or New York, but wherever you go—whether it is to one of the biggest cities in the world or a town center in a rural village—be sure to explore the urban treasures that are waiting for you around every corner, and notice the inspiration available any time of day, any season of the year.

Balcony detail in Hamburg, Germany

EXPLORATION WORKSHEET

Look into the background and history of the place.

When was the city or town founded? What is the population? Are there historic landmarks that are worth visiting?

Determine the lay of the land.

Look at the city/town map and see if there's something that draws your attention, like a town square, a large museum or a university.

Create missions for yourself.

Look up the top three cafés or restaurants. Search for the top ten sights in the city or town. Check out event listings and see if there's anything that piques your interest. Make checklists; they're useful and fun to compile.

Go off the beaten path.

Try to find out where the locals congregate, eat and attend events. If you have friends who have been in that city, or maybe even live there, ask them what they would recommend you do. When I went to Buenos Aires in Argentina, I took a street-art walking tour. It was one of the best things I have ever done in a city. Not only did I see beautiful artwork because of the tour, but I also walked through residential and nonresidential areas I might not have seen otherwise, and I learned a lot of tidbits from the tour guide. It allowed me to roam around on my own later with confidence.

Find museums or galleries worth visiting.

It doesn't have to be an art museum. In Hamburg, you can find a spice museum because of the city's location on the River Elbe, which is part of a trade route. Not only is the building and its surroundings picturesque, but the museum itself is very interesting, with a mix of old photos, vintage advertisements and displays with burlap sacks of spices providing the scents that accompany the experience.

Look for unusual neighborhoods to explore.

Oftentimes, quirky stores, street art and historic houses can be found in older and transitional neighborhoods.

Visit art and craft markets, farmers' markets or flea markets.

Be sure to visit unique markets and festivals. You will meet local artists and can ask them about the inspiration for their work, buy regional foods, and experience the culture of the city.

TAKE PUBLIC TRANSPORTATION WHENEVER POSSIBLE

Taking public transportation in a city whenever possible provides some wonderful benefits. You can explore and get a feel for your surroundings, and it's great for people-watching. Check out the schedules for buses, trams, light rails, trains and subway systems. Look into whether the city has a bike sharing system. One or a combination of these will usually allow you to get wherever you want to go.

If the city has a lake, or is located on a river, check to see if there is a ferry system. Being on a boat gives a totally different perspective and provides many opportunities for taking photos. Another option: trolleys and streetcars, like those in Santa Barbara and San Francisco.

Be prepared. Get whatever transit maps you'll need and plan your routes. Some cities like New York, Washington D.C., London and Paris have extensive underground subway systems. You can pick up a map at the transit office or at main subway stations.

I love to use a phone app called Citymapper. It not only shows you the easiest way to get around in most bigger cities of the world, but it also gives you suggestions as to which public transportation is best to take, or how long walking would take, whether you should enter the beginning, middle or end of a train, and which subway exit to use. The latter has become a lifesaver for me in New York City. You can save and access the information later, even when you are without an Internet connection.

Use common sense when you are traveling in unfamiliar areas and always err on the side of your own safety.

Path in Jersey City, New Jersey, USA

"YOU CAN'T UNDERSTAND A CITY WITHOUT USING ITS PUBLIC TRANSPORTATION SYSTEM."

— EROL OZAN

OBSERVATION

Now that the research is done, it's time to go out to find and collect inspiration. Strive to gather things that trigger memories of what you experienced in the city or town center. Get close to the city and the people.

Things to do:

1. **Observe.** Visit the city or town and observe it from different perspectives. Walk around on your own or take a guided walking tour. Go to a café in a busy location and sit by the window. Watch people for an hour, and talk to people if the opportunity presents itself.

2. **Record.** Write down what you feel, smell and see. Record some of the sounds. It's so much fun to listen to them later, bringing back memories while preparing for or while creating a work of art.

3. **Collect.** Draw buildings, doors, signs, etc. Open your eyes to details. Don't be concerned about the quality of your sketches. The key is to pay attention and make discoveries.

4. **Shoot photos.** Photograph street art and get inspired by colors, shapes and other elements that are unique to that city or are in categories that are of particular interest to you. For example, I am drawn to iron fences, graffiti, doorways and windows.

1. *Sketch of Jersey City skyline*
2. *Making a plan for the day at a Parisian café*
3. *Inspiration: Pattern for a stencil or stamp on a house in Jersey City*
4. *Inspiration: Color combination on a house in Singapore*

REALIZATION

A photo of ironwork, taken in Athens, Greece, as well as a photo of a mural taken in Buenos Aires, Argentina, served as inspiration for creating a stencil and graffiti-layering in this chapter. I later used these techniques to create a mixed-media canvas.

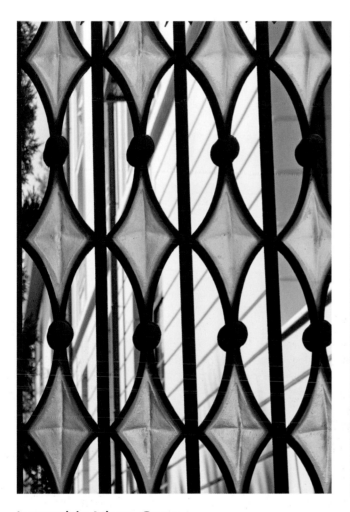

Ironwork in Athens, Greece

I love all the different shapes in this ironwork: the large diamonds and ovals connected by the small circles—together, they create an intriguing pattern. It immediately inspired me to make a stencil. I could also see how color applied in the openings of the diamonds would look, and I love the teal blue glass as an inspiration in and of itself.

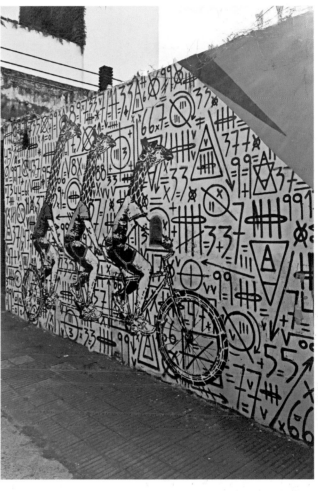

Mural in Buenos Aires, Argentina

Though I love the giraffes on the bicycle, which were done by a group of graffiti artists called Stencil Land, I'm most drawn to the background of this mural, created by a single graffiti artist whose name is unknown to me. The black and red color scheme with numbers and geometric shapes made me look for hidden messages while also providing a beautiful, cohesive pattern. It reminds me of the late artist Jean-Michel Basquiat's way of incorporating signs and symbols into his artwork, and I was immediately inspired by how this would work in a background applied with markers or pens.

STENCIL BACKGROUND

Stencils are wonderful tools for creating repeating patterns or images. If created with lasting materials like acetate, they can be used over and over again. This proves to be especially handy when a stencil has a generic but intriguing pattern. Stencils can be bought ready-made, but they can also be easily cut by hand or with an electronic cutting system, which adds a unique note to your artwork. I turned the pattern in the photo of the ironwork into a stencil.

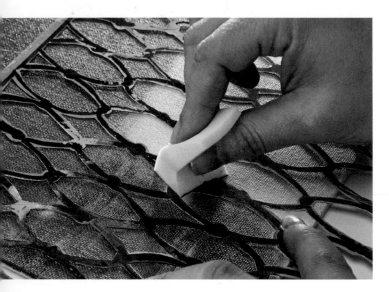

WHAT YOU'LL NEED

- Acrylic paints
- Clear transparency (acetate) sheet (I use Dura-Lar)
- Cosmetic sponge wedge
- Permanent marker (I use a black Sakura Permapaque marker)
- Pre-painted substrate (I use a 6" × 6" [15cm × 15cm] canvas board)
- Printout of image
- Self-healing cutting mat
- Sharp craft knife
- Stiff-bristle stencil brush (optional)
- Straightedge or ruler

Preparation

If you own and are familiar with Photoshop, you can easily transform a photo into a black-and-white image, resize it and line it up in a repeating pattern. However, you can also do this with simple photocopies if you do not use graphics software.

Take the digital file of your photo and open your printer menu. Most printers offer the option to choose a black-and-white print setting, which saves toner and also makes it easier to trace the relevant parts. Size the pattern for a letter or A4 stencil by choosing different numbers of copies per page. The printer preview shows how the image will look when arranged in tile form on the paper. For this pattern I decided that six copies reflected the desired size of my pattern. At this point, the pattern will not be perfectly aligned.

Print the images on one sheet of paper.

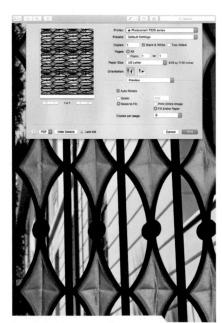

Printer preview screenshot

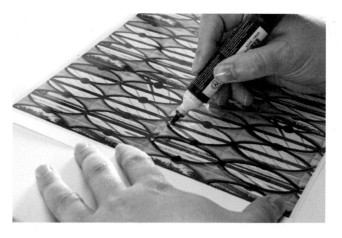

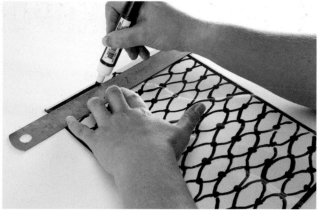

1 Align the transparency sheet over the printout and trace the areas you want to keep for the stencil with a black permanent marker. Even though the ovals have a line down the center of them, I am not tracing those verticals. This makes it a very easy stencil to cut. There will be oval-shaped openings and diamond-shaped openings, as you will soon see.

Tip: Once you come to the end of one of the six sections on the printout, move the acetate so the pattern is accurately aligned, and then continue drawing.

2 Once you've filled the acetate sheet with the line drawing, use the same permanent marker to draw a border of at least ½" (13mm) around the stencil. This will stabilize the stencil after it is cut and give you something to hold while you're working with it.

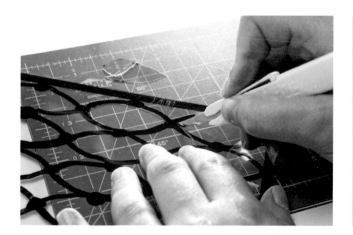

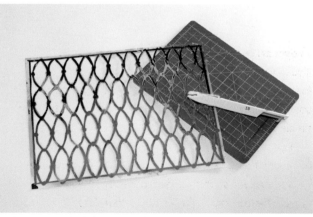

3 Cut out all "white" spaces (the areas of the acetate that are not covered with marker lines) using a sharp craft knife atop a self-healing mat.

4 To complete the stencil, continue until only the black lines and outer border remain.

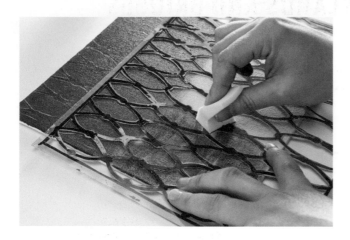

5 To use the stencil, apply paint to your pre-painted substrate with a cosmetic sponge wedge. For sharp, crisp images, dab the paint onto the sponge, then dab some of it off, loading only a small amount of paint at a time. Too much paint will seep underneath the stencil. Alternatively, use a stiff-bristle stencil brush.

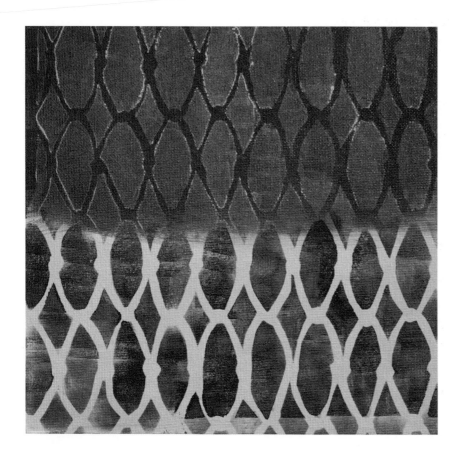

6 In my sample, I had painted the canvas board half red and half yellow. Using the stencil, I added yellow paint through the stencil onto the red area, and red paint through the stencil onto the yellow area.

STENCILS, MASKS, ISLANDS AND BRIDGES

A *stencil* is a pattern through which you apply paint. A *mask* is the opposite of a stencil: you apply paint around it. Whatever the stencil or the mask covers will be left unchanged by paint when the stencil or mask is lifted up from the surface.

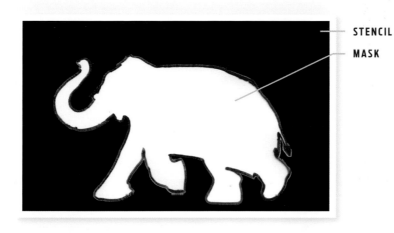

STENCIL

MASK

Stencil vs. Mask
In this example, my acetate sheet is shown as black. The cutout of the white elephant is a mask. However, the rectangle of acetate left after the elephant has been cut out of it is a stencil.

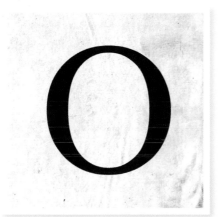

Islands and Bridges
The most important thing to remember when cutting a stencil can be summed up in this line: All islands need bridges. (A bridge is a connection from one thing to another.)

Look at the letter O, for example. The white center of the O is an island. In a stencil, it would fall out without something to hold that center section in place. A bridge is a connection between the island and the area of the stencil beyond the letter O.

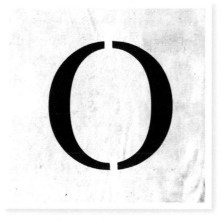

Create a Bridge
To make sure the solid oval doesn't get lost, bridges are needed. You can create your own bridges by simply drawing lines to connect the white areas (but remember not to cut out those lines!). I use a white pen so I won't get confused and can keep track of what areas to leave alone and which to cut away. Remember, for lettering, you will be cutting away the areas that are drawn in black. This is different from the example of the ironwork shown earlier.

A quick note: Make sure you don't violate any copyright when creating a stencil or other artwork.

GRAFFITI LAYERING

Layers add visual interest and depth to artwork. They're a crucial part of my work and something I hope you will incorporate into yours.

When adding layers to your work, repetition of some elements helps create a cohesive and appealing design. Usually, this can be achieved by repeating a color, pattern or form. Repeated elements in a work of art create visual interest.

WHAT YOU'LL NEED

- Acrylic markers
- Blank paper
- Stenciled substrate (from previous demonstration

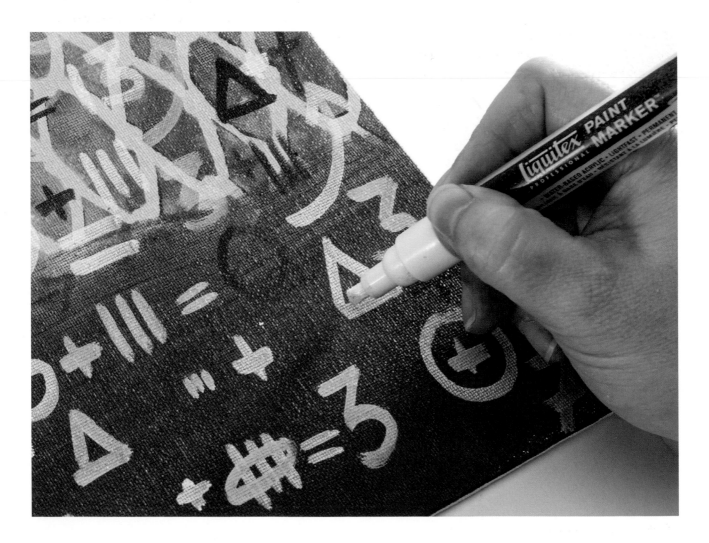

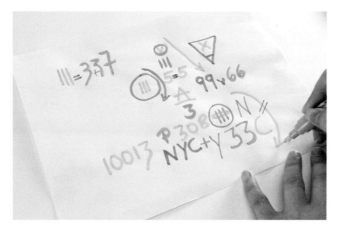

1 Analyze the patterns on the mural with the giraffes (page 25) and create your own code by writing on a piece of printer paper. I used various elements: numbers, letters, arrows and triangles. Use different-colored markers, as his will help you visualize your code.

For my painting at the end of this chapter, I chose a commercial building in New York City as the subject matter. I wrote down the building's zip code and street number, as well as the letters NYC.

2 Start writing on your stenciled substrate. Alternate marker colors when you're inspired to. For this example, I chose the red I had used for the background, and gray and off-white markers to lighten the darker red area.

Tip: If you feel the background might become too dark, choose a neutral or light color.

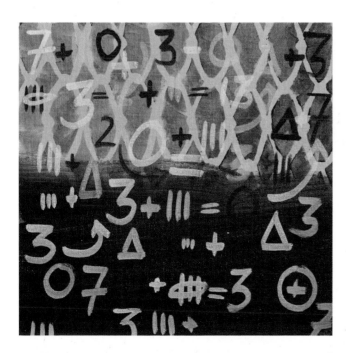

3 The result is a fun, layered background that's ready to be finished with a painting on top.

PRINCIPLES OF ART

We often use the principles of art intuitively, but knowing them in a more structured way allows you to consciously put them to use in your work. Think of the principles as you might think of a recipe: as a starting point. Use them as guidelines when you're stuck or can't decide why something might not look right; let the principles provide information for making changes.

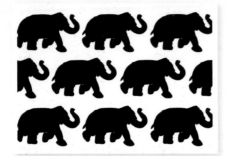

Pattern
Pattern refers to the repetition of a design element. It can be made up by the repetition of colors, lines, shapes and textures. Pattern can add interest and create the mood of an artwork.

Movement
Movement takes you on a journey in the artwork and directs the eye, often to the focal area. It can be reflected through lines, edges, colors and shapes. Movement gives a sense of structure and organization.

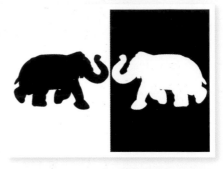

Contrast
Contrast is the difference between elements in an artwork. This can be color (dark and light, opposite colors on the color wheel), texture (smooth and rough), size (small and large), and more. Contrast makes artwork more interesting.

Balance
Balance refers to how the visual elements are arranged. These elements can be shapes, colors, texture, space, values and more. There are two kinds of balance: symmetrical and asymmetrical. In symmetrical balance, elements on one side are identical or similar to the elements on the other side. This results in a more formal, stable (or comfortable) look. In asymmetrical balance, elements are different from side to side. Movement is created by diagonals that provide the balance.

Emphasis
Emphasis refers to the center of interest, or the focal point. It can be created with contrast, differences in color, texture, shape, or amount of detail. Emphasis in an artwork tells the viewer what to look at first and what is most important.

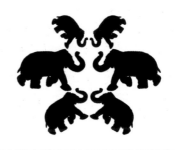

Unity
Unity is the way different elements in an artwork connect with each other to become a whole. Lines and shapes, and colors and textures work together, producing harmony. Think of an orchestra with different instruments and sounds coming together.

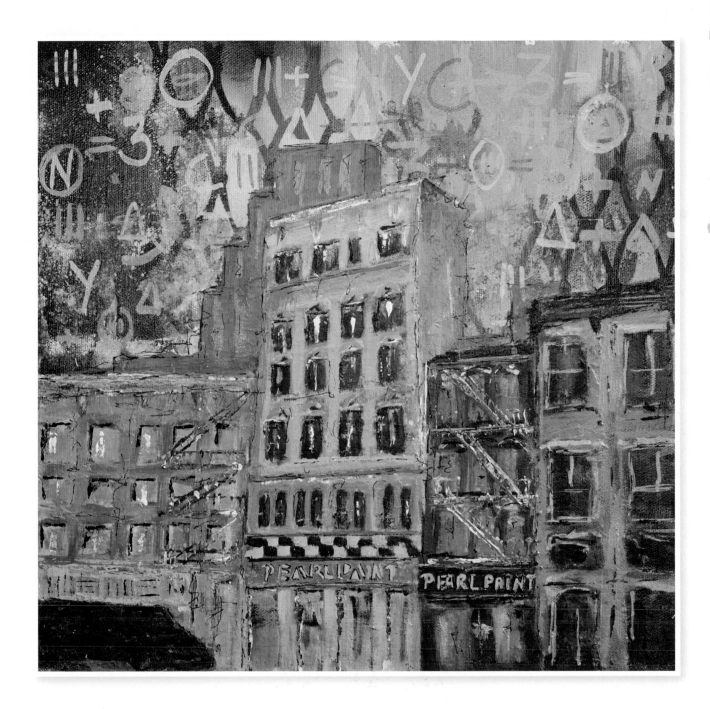

GONE DESTINATION

Nathalie Kalbach
Acrylic paint and marker on canvas
12" × 12" (30cm × 30cm)

Inspired by a closed-down, popular paint supply store in New York City. Uses the background technique demonstrated in this chapter.

3

GETTING IN TOUCH WITH NATURE

Nature has always inspired art and can be viewed as art in itself. Taking inspiration from the natural world connects us to our roots and our essence.

KIEFER

Nathalie Kalbach
Acrylic paint, spray paint, mediums, plant and rubber stamp pieces
16" × 16" (41cm × 41cm)

Inspired by nature and German artist Anselm Kiefer. The word Kiefer translated from German into English means pine.

ENJOYING NATURE'S BOUNTY

Driving towards Bryce Canyon, Utah

Even though I am a self-proclaimed city girl, I do love to be out in nature and frequently use time outdoors to search for inspiration for my artwork. It was wonderful being a teenager in a small, rural German town surrounded by farmland. In the summer, my friends and I would ride our bicycles to a lake about three miles from town to go swimming. Up a hill, down a hill, we were surrounded by a forest. Some of my friends lived on farms and I frequently helped them with their chores, especially during harvesting time. Physical labor connected me with the rural environment. But my friends and I also went off the beaten path.

When I was older, before I moved to Hamburg, my friends and I would hike into the forest and camp overnight. I won't lie, I was still a city kid; bugs and spiders would freak me out, though I understood that I was intruding on their natural habitat and not the other way around. Collecting leaves, stones and twigs became a hobby of mine. I displayed them on shelves, loving them for their sculptural qualities. Later, I incorporated some of what I collected into my artwork.

This deep-rooted fascination with nature continued into my adult life. Over the years my husband and I have traveled extensively in the United States, even before we moved here. We would visit our American family and tie in road trips to explore state and national parks and other sites. The beauty and variety of the American landscape is mind-blowing and a constant reminder of what a small part we human beings are in this ecosystem. I kept travel journals and I collected pieces of nature wherever allowed, adding pressed flowers to the pages as well as maps, tickets, and other printed ephemera from parks and visitor centers.

I love taking photos and I am especially intrigued with close-ups of anything that would offer interesting texture. Texture is a very important element in my artwork and often develops from something I have seen in nature. Whether rock formations or gnarled wood, meandering

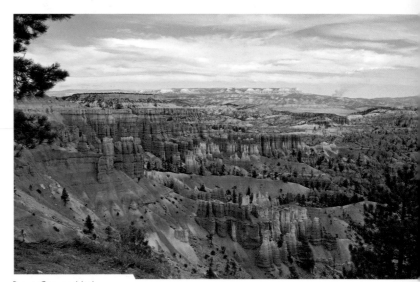

Bryce Canyon, Utah

lines traced in the sand or the veins of leaves, I have to stop and take a closer look—and a picture for later reference.

I am also constantly inspired by the color combinations found in nature. For example, at every turn in the road on a trip through Utah, the rocky formations presented a new and unexpected palette. Seasonal changes, such as nature's bounty in the form of flowers and leaves, also present color ideas as if on a silver platter.

It takes more effort to get out into nature when living in such a densely populated city as where I am now, but a ten-minute bike ride takes me to Liberty State Park.

Hiking in Zion National Park, Utah

Liberty State Park, New Jersey; Statue of Liberty at the Secret Beach

From there it is easy to visit the so-called "Secret Beach," a little spot with few visitors and a view of the bustling city of New York across the Hudson.

Whenever I am in nature I feel like time slows down. Whether it's on a farm, in the woods, at the beach or in a national park, I feel less stressed. I am invited to be curious, to get actively involved with my surroundings, and to enjoy the amazing beauty of what I can see and touch. In nature, finding inspiration for my artwork comes easily.

Liberty State Park, New Jersey; plants at the Secret Swamp

EXPLORATION WORKSHEET

Find a place to experience nature.

You don't have to travel far. A park or the little wild areas of a garden can serve as a perfect spot to explore nature and find a spark for your artwork. You can even find consciously planned natural environments within a big city. The High Line in New York was landscaped to ensure that the vegetation offered different colors and inspiration throughout the year. Just like in rural settings, it's a valid way to see nature.

Examine the essence of a particular place.

What are the flora and fauna? What's the geography of the location? How about the animal habitat? What is the best season to visit, or are repeat visits the ideal way to experience the setting?

Think about what's important to know about the place.

What is the climate? What footwear and clothing are needed? What precautions and preparations are necessary? For example, have the right garments to prevent contact with poison ivy or getting sunburned. Be aware of whether there are bears in the area, or if mudslides are common. Know what to do if dangerous circumstances were to arise.

Take a nature trail.

Self-guided nature trails allow you to set your own pace. You can spend a lot of time in one place, or you can move quickly each time your eye catches something new.

Prepare a collection box.

Have a small, lightweight box ready for keeping what you collect while out in nature. Read up on the rules of the location, too, so you know what you can take and what you must leave untouched and pristine.

Take guided tours.

Guided tours provide information from those who know the area and can help you discover the special features you might not have otherwise noticed. You'll even find walking tours through nature in big cities, like Central Park in New York.

VISIT NATIONAL PARKS

Yellowstone National Park is one of my favorite places. In 1872 the U.S. government had the foresight to preserve this amazing and precious landscape as the world's first national park, providing an example for other nations. National parks now exist in almost one hundred countries.

National parks accomplish two things. First, they identify and preserve scenic wonders. Second, they provide a way for visitors to access parts of these treasured places. Some areas can be easily reached by car or on foot via a short walk; other areas require more rigorous hikes or climbs.

Visual artists like Ansel Adams and Thomas Moran have long drawn inspiration from these outdoor museums, as have many writers.

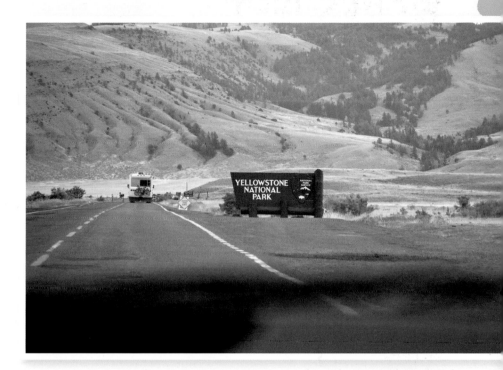

Entry to Yellowstone National Park, Wyoming, USA

Here are tips for your trip to a state or national park:

➤ To stay at a lodge or campground, plan and reserve a place well ahead of time. Space is limited.

➤ Be sure to take advantage of the park rangers' guided tours, hikes and talks offered to visitors. Many are free.

➤ If possible, get out of the car and go for a hike. Find a trail that fits your physical abilities and prepare for it. Wear the right clothing and footwear, and bring food and water. Know the rules and recommendations regarding wildlife and safety measures.

➤ If you're visiting a park with an artist in residence program, be sure to take advantage of it!

"WHAT A COUNTRY CHOOSES TO SAVE IS WHAT A COUNTRY CHOOSES TO SAY ABOUT ITSELF."
—MOLLIE BEATTIE

OBSERVATION

Once you've reached your destination, it's time to focus on the things that jump out at you. Not only can you gather what can trigger memories later, you can also collect items that you can actively incorporate into your future artwork. It is fine to get sidetracked and to take time to notice little details.

Things to do:

1. **Observe.** Stop and sit down for a while. Look around: What is the color spectrum? Is it bright, earthy, cold or warm? Are there varieties in shapes and forms?

2. **Record.** Listen to the sounds of water, birds, animals and other compelling sounds, whether quiet and subtle or boisterous and loud. Make a rubbing of a stone or wood form by placing paper over it and rubbing the paper's surface with a soft pencil or crayon. Take notes of things that you recognize as well as that which is unfamiliar.

3. **Sketch.** Document the color palette in your sketchbook. Draw lines, shapes and forms you see. Zero in on plants; take note of wide views of the landscape.

4. **Shoot photos.** Get close and take photos of the tiniest detail, like lines in wood grain, striations in rocks, or organic structures in lichens, mosses and ferns.

5. **Collect.** Gather things you can incorporate into your artwork, like branches, rocks, shells or things that can be used as tools for mark-making. Plan ahead and think of it as a nature-art scavenger hunt. Decide on a focus in advance (mark-making tools, items that are in a particular color range, smooth rocks or jagged ones, etc.), and then take plenty of detours to further the experience.

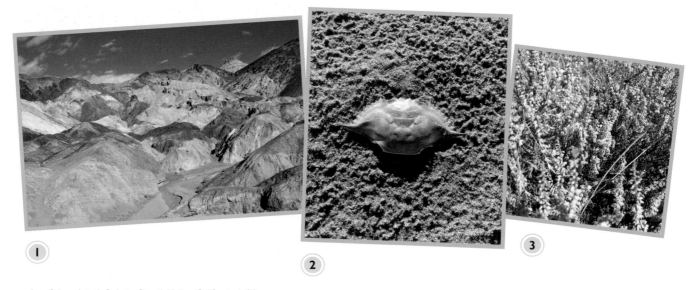

1. *Colors, Artist's Palette, Death Valley, California, USA*
2. *Texture, crab, Liberty State Park, New Jersey, USA*
3. *Color and shape, heath in Lüneburg Heath, Germany*

REALIZATION

These photos of geysers in Yellowstone National Park served as inspiration for texture and color in my artwork. I will share the techniques I used based on these images so that you, too, can create these effects.

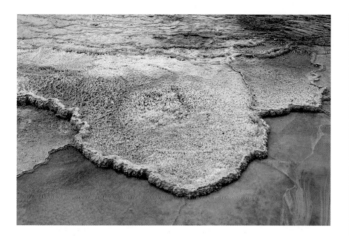

Geyser Sinter Deposit

Here I'm intrigued by the texture on the side of the geyser. Dissolved silica is ejected by the geyser, which cools and dries to create these undulating forms called sinter. To me, this deposit looks like a petrified version of a wave crashing onto a beach. The layers and the different earthy nuances of color also speak to me.

Edge of a Geyser

I love the color combination of deep blue, teal, white, off-white, orange and sienna; this is nature providing a perfect palette. Bacteria, algae and different water temperatures cause these intense shades of blue, as well as the colors in the sinter. Nature knows a thing or two about the color wheel (blue and orange are complementary hues).

ELEMENTS OF ART

When you look at art, you will see how the artist used form, shape, line, color, value, space and texture. These are the things we're drawn to. If the principles of art in chapter 2 can be seen as a recipe for art, then the elements are the ingredients. Each of the ingredients has its own qualities. They reinforce each other and, combined, make up the whole: the work of art. Adding the right ingredients—the elements—to your art makes the work more interesting, and developing your own recipe results in your individual style.

Lines

Lines are the most basic element of art. Lines can be straight, curvy, horizontal, vertical, diagonal, dotted, broken, thin or thick, light or dark. They can be smooth, rough, bold, messy or jagged, triggering different emotions for the viewer as well as directing the eye.

Shape

Shape is two-dimensional, the line that connects with its own end or crosses with another. Shapes can also be formed by colors and value changes. They can represent reality or be abstract. Shapes can be geometric (square, circle, triangle) or organic and freeform.

Form

Form is three-dimensional and can be geometric (cube, cone, cylinder) or organic (animals, people, plants). A form can be viewed from different angles. In two-dimensional visual art, shapes that are created with the illusion of the third-dimension of depth become forms. Usually they're created with light and shadow or contrasts. Squares (shape) can become cubes (form) by adding depth. Form takes up space, either real or implied.

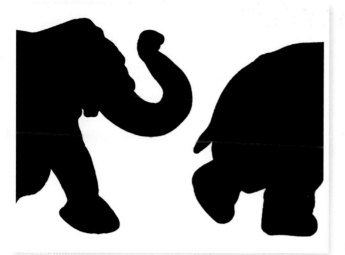

Space

Space is the area in which an artwork is organized. The main objects take up positive space while the area around them is the negative space. On two-dimensional artwork, the illusion of three-dimensional space can be implied by creating size differences. Smaller objects appear farther away, as do objects that are higher up on the picture plane. Larger objects, placed lower on the picture plane, appear closer. Overlapping and layering objects as well as varying values in color can also imply three-dimensional space. What is shown with sharper detail also appears closer, while soft edges or muted colors imply distance.

Color

Color is the reflection that we see after light hits a surface and gets absorbed. This depends on the surface (porous versus nonporous, light versus dark). The way in which an artist uses colors, the combination and value choices, creates the artist's own style. Colors can evoke feelings and memories for the viewer, as well as for the artist. To me, color is the most prominent and exciting element in artwork.

Value

Value is the scale of a color going from dark to light. Colors can be lightened with white, toned down with gray or shaded with black, creating different values and tones of a single color.

Texture

Texture refers to the tactile look or the actual feel of a surface and engages the viewer's sense of touch. It's an expressive tool to underline the message of an artwork. Note that it can be implied or actual: A painting can suggest a rough texture while remaining totally smooth on the substrate. Different lines or shapes can create visual texture. Surfaces that are matte appear a bit rough, while glossy and sparkling surfaces are often identified by the eye as smooth. Actual texture can be created by thick impasto techniques or paint applications so the surface becomes three-dimensional. It can also be created by using collage elements, including papers, fibers, fabrics and found objects.

LAYERED TEXTURE

Texture gives a lot of interest to a piece of artwork. There are many ways to create texture. I use texture mediums, sometimes mixed with paint, as well as texturing tools to approximate the texture I see in my inspiration photos. I also work with multiple layers. When I look at a photo, I mentally take it apart so I can number the steps in the order I will use for each layer.

WHAT YOU'LL NEED

- Acrylic paints (I used teal, Phthalo Blue, Unbleached Titanium, red, orange and Raw Sienna)
- Artist tape (½" [13mm] or 1" [25mm] width)
- Ceramic Stucco medium
- Fan brush
- Glass Beads medium
- Gloss Heavy Gel medium

- Household sponge
- Natural Sand medium
- Palette or palette paper
- Palette knife
- Rag
- Rubber brayer
- Substrate (I use a 6" × 6" [15cm × 15cm] canvas board)
- Super Heavy Gesso

Sketch layering order

1 Apply two mounds of Gloss Heavy Gel medium onto your palette. Use a palette knife to mix blue acrylic paint into one. Clean the knife and mix teal paint into the other.

The ratio of gel medium to paint depends on the kind of paint you're using (less paint if it's highly pigmented). The goal is to create textured paint, not a translucent glaze. The amount of gel medium and paint needed will also depend on the size of your substrate.

2 Apply the colors side-by-side on the substrate, allowing them to blend where they meet.

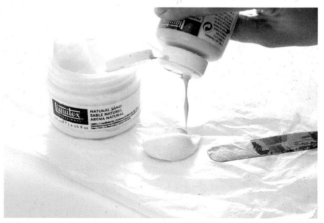

3 Roll a rubber brayer through the paint to spread it out, but keep your wrist loose and apply very little pressure to the brayer. This will create a rippling effect and keep a lot of the texture. Think of it like lifting peaks when icing a cake. Let it dry.

4 Mix some Natural Sand medium with Unbleached Titanium acrylic paint.

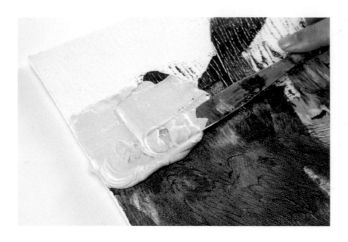

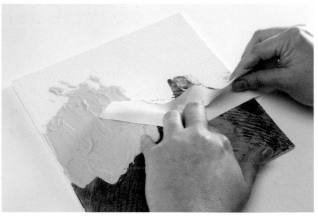

5 Apply the mix with a palette knife, pushing toward the edge while lifting and pushing the knife to get a staggered texture effect. Let it dry.

6 Create a dam using artist tape. Fold the tape lengthwise and secure half to the substrate in a wavy form. Leave the other half folded upright as the retaining wall.

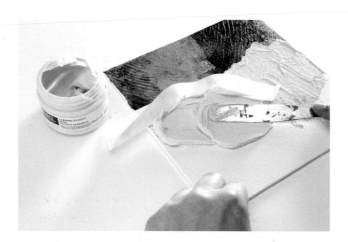

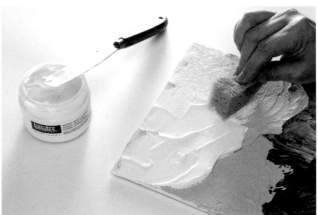

7 Scoop some of the Ceramic Stucco onto a palette knife and apply it in layers using the dam as a border against which to build up the texture. Remove the artist tape while the Ceramic Stucco is still wet. Let it dry.

Note that heavier mediums require more time to cure. Drying time will also depend on the current climate and how thickly they are applied.

8 Apply Super Heavy Gesso with a palette knife and spread it out in the desired area. Use a piece of household sponge to pounce into the wet Super Heavy Gesso, creating a bubbly texture like the sea foam of a wave crashing on the beach. Work fast and use very little hand pressure. Let it dry (this can take twenty-four hours or more).

ACRYLIC GELS AND LAYERS

Acrylic gels and primers are great for creating the desired texture in your artwork. Many different acrylic paint manufacturers offer a wide range of acrylic gels and primers, with a variety of different names. The durability of your artwork is important. Using the right medium for the right application ensures that undesired cracks, chipping, yellowing or adhesion problems do not occur over time. All of the mediums can be used as they are and painted over with acrylic paint, or the acrylic paint can be mixed in. When mixed with a medium, paint colors may change. For predictable results be sure to take time to experiment. (Or embrace the unpredictable!)

Wet acrylic gels and other primers

1. Gel Medium *2. Natural Sand* *3. Ceramic Stucco* *4. Glass Beads* *5. Super Heavy Gesso*

GELS

Gel mediums are essentially acrylic paints without pigments (colorless acrylic paints). When wet they are milky-looking but they dry clear. If used correctly they can change the viscosity of acrylic paint without changing the binding of the paint to the surface or the color. They exist in glossy and matte finishes, and their usage depends on the desired sheen. They also come in different bodies ranging from a normal thick gel consistency to heavy to super heavy. The thicker and heavier the medium, the more marks and peaks can be created with brushes, palette knives and other tools, and the better these marks and peaks will remain visible.

Natural Sand is a fine texture gel that dries to look like the surface of semi-wet beach sand. It can be used to create delicate marks and texture or as a ground for pastels and charcoal.

Ceramic Stucco is a fine texture gel that has the surface finish of an Italian fresco. It dries to a light gray. It is also a great ground for pastels and charcoal and can be mixed with acrylic paint, creating a slightly grayed-down tone of the color.

Glass Beads is a medium-bodied gel that contains plastic micro beads that give it a consistency similar to coarse sea salt. It dries clear and reflective with a beady texture. When mixed with acrylic paint, it loses some of its reflective properties upon drying.

PRIMER

Gesso seals and primes porous surfaces and is the perfect ground for acrylic paint. The most common gesso is white, but gesso is also available in black and clear. You can mix acrylic paint with gesso to create a colored ground; mix clear with white for a tinted ground; or black with white for a grayed-down ground. Gesso also comes in different viscosities depending on the brand. You can find smooth, creamy gesso (the standard) as well as heavy and even super heavy gessoes for thick impasto and more sculptural effects.

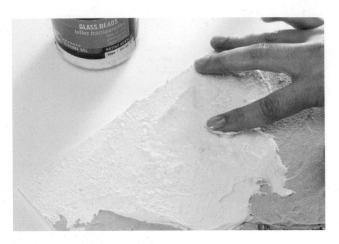

9 Spread Glass Beads medium over selected areas of the dried surfaces to add sparkle, like sun glinting off of a wet beach. Use your finger to make sure the beads are evenly distributed and dispersed, and to ensure that the reflective quality remains. Let it dry.

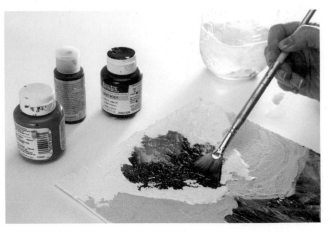

10 Apply a small amount of red, orange and Raw Sienna paint with a wet fan brush. Let the paint set for a couple of minutes, but do not let it dry all the way.

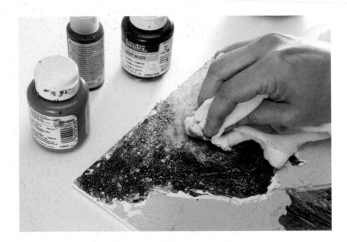

11 Use a damp rag to take off some of the paint, revealing the white texture underneath. Let it dry.

DON'T TOUCH

Nathalie Kalbach
Acrylic mediums and paint on canvas
16" × 12" (41cm × 30cm)

Inspired by geysers at Yellowstone National Park. Uses the techniques demonstrated in this chapter.

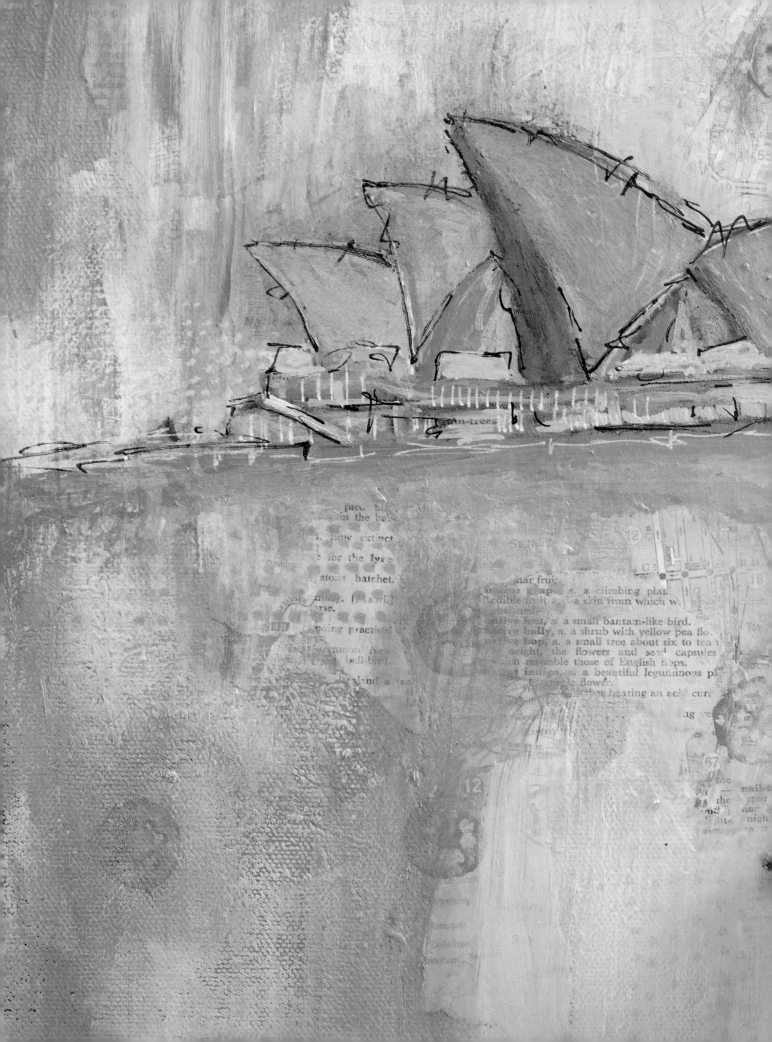

4 TAKING IN NEW EXPERIENCES WHILE TRAVELING

Traveling introduces us to new sights, sounds, tastes and smells as we explore different cultures and lifestyles. It's not just about the destination; it's also about how we get there.

SYDNEY

Nathalie Kalbach
Acrylic paint, acrylic markers, maps,
Australian English Dictionary paper and
gum tree nuts on canvas
9" × 12" (23cm × 31cm)

Inspired by the Sydney Opera House and the Royal Botanical Garden in Sydney, Australia.

JOURNEYS, JOURNALS AND MEMORIES

Traveling has always been a part of my personal life and is the incubator for much of my artwork. Italian on my dad's side, I spent my summers in Italy with his family when I was a kid. Starting in first grade I flew there by myself. My mother drove me to the airport and at check-in my very own stewardess took me under her wing. I wore a little plastic badge holder around my neck with my name and pertinent details just in case I got lost, though I never did! I was given ice cream and comic books, and I got to visit the pilot's cockpit; and so the adventure began. I still have fond memories of this special time on the plane. To this day, the time en route is part of the experience for me.

One of my favorite travel stories happened in 2010 when the volcano Eyjafjallajökull erupted and for several days all air traffic was suspended; my husband and I, along with friends from Denmark and Sweden, got stuck in Warsaw, Poland. We couldn't get out by rail—all trains were overbooked. Renting a car wasn't an option since the prices were surging, and no rooms were available at the hotel where we had been staying. The city was jammed with people arriving for the Polish president's funeral and with people who couldn't leave. When a friend's father, a taxi driver in the city, offered to drive us home, we soon realized that what struck us as a crazy notion would actually be a bargain—less expensive than the plane tickets, even if it would take quite a while. So we rode in a taxi cab from Warsaw back to Germany, an eleven-hour trip, while our friends continued another four to Denmark and several more to Sweden. It was the longest taxi ride any of us had ever taken. Five adults in a taxi, taking turns in the least comfortable seats, laughing a lot. Indeed, a "Happy Cab," as the logo on the car indicated. Some of the jokes, memories and conversation made its way into art journals and other artwork. It was a travel experience I will never forget.

Besides seeing new and exciting sights, I love to travel because of the connections I make—with other people, with a different way of living, with a different culture. Teaching art workshops around the globe has offered me opportunities and insights I could not have imagined. I went with new friends to a temple in Malaysia, shared a Sabbath dinner with my host family in Israel, and picked hops with friends of friends in California who own a brewery. These memories are emotionally potent, and they provide colors, patterns and images that I incorporate into my artwork and into my stamp and stencil designs.

Nathalie in 1978 in Sicily, Italy

Traveling in the Happy Cab from Poland to Germany

Early on in my travel adventures, I started taking journals with me. I take notes about what I see and experience, the people I travel with, and people I meet during my journey. I sometimes even invite them to write a few lines or draw something on one of the pages. I scribble quick sketches and glue paper ephemera.

I store my journals in my studio, along with photos of my travels, and often pull them out to peruse when I am stuck in my creative process. They carry me back to other times and places, and spark ideas.

The memories of a meal in a different country, the smell of a food market so unlike what I find at home, the snippet of a conversation in a language I don't understand, the colors of the landscape glimpsed as I pass by in a car or train; these and more all find their way into my studio process. These memories are emotionally potent, providing color, pattern and image inspiration that I incorporate into my artwork, and into my stamp and stencil designs. Traveling has opened my mind and heart.

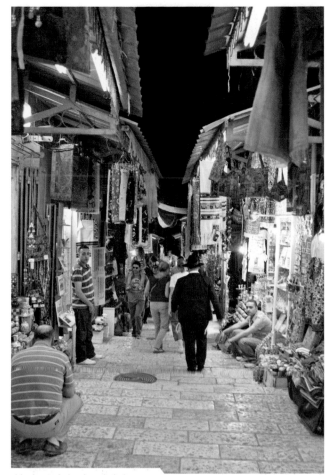

Market in Jerusalem, Israel

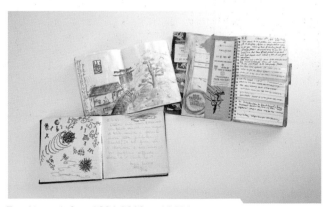

Travel journals from 1984, 2009 and 2014

Batu Caves, Gombak, Malaysia

EXPLORATION WORKSHEET

Research what's special about the place you're going to visit.

New Orleans is famous for its musical bar scene and the French Quarter; Hawaii is known for its beaches and volcanoes. What do you know about your destination? If you know just a little, what do you need to find out before you depart?

Watch movies or read books to help set the stage for the trip.

There are so many movies and books that can set the mood and act as a part of your research. Some may be fictional (watch the movie *Amelie* and you are transported to Paris), some are non-fiction (pick up a book with pictures of cathedrals and art you might be planning to see). This lets you piggy-back on the research that others have already done.

Find out if there is local cuisine.

Chili is different in Cincinnati than in Dallas; Mexican food in San Diego isn't the same as in Mexico City. Almost all cities and small towns have food markets where you can try things without having to go to a restaurant, and the way the food is displayed—with so many colors and patterns—is inspiring. Plus you get the feel and sense of the everyday life in a particular place, along with snacks and food for picnics.

Research the local customs and practices.

Know about them and pack the right things to wear. For example, when visiting a church or temple you might have to dress more modestly than for the rest of your trip. Respect the prohibitions on photographing people in certain places or situations. If in doubt, ask.

Visit local art supply stores or take art classes.

I love scouting out local art supply stores and discovering new and inspiring art supplies to bring home. It can also be fun to take an art class, a great way to connect with like-minded people in a different country.

Prepare an art-on-the-go kit.

Pack some supplies to create art while you travel (a full description of my art-on-the-go kit is on the next page). With materials in hand, even brief moments can provide opportunities to sketch, doodle and write. And when there is more time, you'll be especially glad you brought the kit.

ART-ON-THE-GO KIT

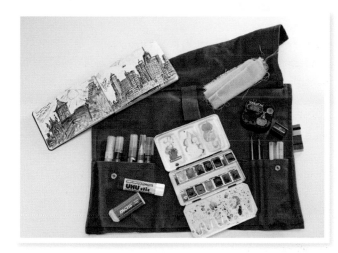

Packing an art-on-the-go kit is a great motivator. It ensures that you will make art while you're traveling, while you are in the moment. Keep the kit light; you're more likely to use it if it's small, convenient and portable. Remember that you will often have only a short amount of time and a small space like your lap, a table at a café or the tray in front of you on a plane.

Here is what I pack in my kit:

➤ **Watercolor sketchbook.** Mine is about 3½" × 5½" (9cm × 14cm) and serves as a sketchbook, art journal and travel journal all at once.

➤ **Watercolors.** I pack single watercolor pans in a small metal tin, dry watercolor sheets or a travel-size watercolor set.

➤ **Water brush.** This brush can be filled from any sink or water bottle and prevents spills and messes.

➤ **Mechanical pencil** for sketching.

➤ **Eraser.**

➤ **Small rag** for cleaning the brush or dabbing excess paint.

➤ **Black India ink pens (permanent ink).** These pens are waterproof and wonderful for linework and journaling. Pack at least two different nib sizes: fine and medium.

➤ **Acrylic markers.** I limit myself to three, though it's tempting to pack more. I choose colors that allow me to do things I can't achieve with watercolors. The reason for paint pens instead of tubes of paint is ease of use. I use paint markers that work with a pumping system, which allow me to pump paint through the nib onto a surface (like a plastic saucer) and then apply the paint with a brush. Essentially, the marker acts as a travel-size container filled with acrylic paint, and the clean-up is with water, the same as watercolors.

➤ **Small glue stick** to adhere ephemera.

➤ **Small solvent-based (permanent) ink pad** for making fast marks with found objects. Always store it in its own separate zippered plastic bag and secure the lid with tape or a rubber band.

➤ **Small bag or box** that can hold all the supplies.

Be on the lookout for items than can serve as mark-making tools (sticks, bottle caps, packaging material, etc.). Use them while you're on your journey and add them to your art-on-the-go kit if there's room. Pick up open stock art supplies to try out and add to the kit (a brand that's new to you, a pencil or pastel in a favorite color). When we're home, we have endless supplies, but when we travel the items at hand are more limited. Working within these limits often leads to better focus and unexpected discoveries. There's less need to think about technique, so you can spend more time playing and doing!

Cautionary note for air travel: I've never had problems with my markers in my carry on, but to be on the safe side pack them in a clear zippered plastic bag with your other liquids.

"I NEVER TRAVEL WITHOUT MY DIARY. ONE SHOULD ALWAYS HAVE SOMETHING SENSATIONAL TO READ IN THE TRAIN."

—OSCAR WILDE

OBSERVATION

Begin your travel experience as soon as you leave home. Embrace the moments that might be not so compelling, like waiting in line to board a train or plane. See if you can discover things that give you hints of your destination. Are there people from the country you are going to in the waiting area, do they speak a different language, how does it sound? Are there unique snacks and foods along the way? Take note of all the little details and make the journey part of your hunt for inspiration.

Things to do:

1. Observe. Try different foods, go to a food market, smell, feel and taste different things. Are there local art and craft markets; what is the trend or what are the supplies being used? Is the fashion style different from where you are from? Are the colors and façades of houses distinctive and how do they differ from what you know? What about the street signs and other graphics?

2. Record. Take photos of what is unfamiliar to you, write about your feelings and emotions when you take in what is different from the norm; find out what is similar to what you know. Record short videos with your phone to capture the sounds of the street—musicians, people talking, the animals. I took a lot of videos when I was in Australia and now have the sounds of flying foxes (gigantic loud bats) hanging in trees at the Royal Botanic Garden in Sydney, and the laughing sound of the kookaburra bird. Videos can transport you right back into the moment in a unique way.

3. Collect. Maps, ticket stubs, business cards from shops and restaurants, postcards and receipts make wonderful items to either include in your travel journal or later incorporate into your artwork as collage elements. Buy small colorful souvenirs like patterned or marbled papers, bookmarks, paper cuts, or items made by a local artist. These, too, can be included in artwork.

4. Create. Play with your art-on-the-go kit to make art.

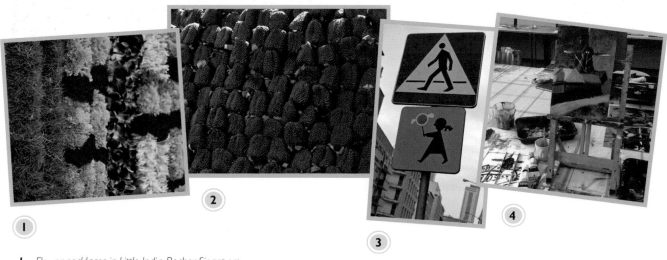

1. *Flower necklaces in Little India, Rochor, Singapore*
2. *Stacked strawberries at a market in Athens, Greece*
3. *School children crossing sign in Poland*
4. *Painting class in Winsum, Netherlands*

REALIZATION

These photos of a windmill and the façade of a house inspired my monoprint painting technique.

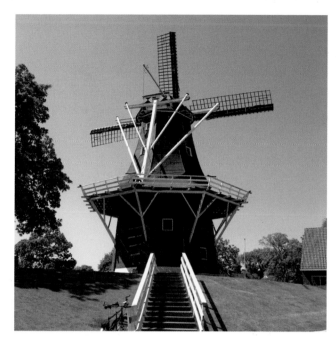

Windmill in Garnwerd, Netherlands

I find the shape of this old windmill interesting. It is a shape that is recognizable around the world, a silhouette that I learned more about when I was in the Netherlands. The position of the sails on a windmill could be used for signals or messages. This concept of a hidden message is something to incorporate into artwork.

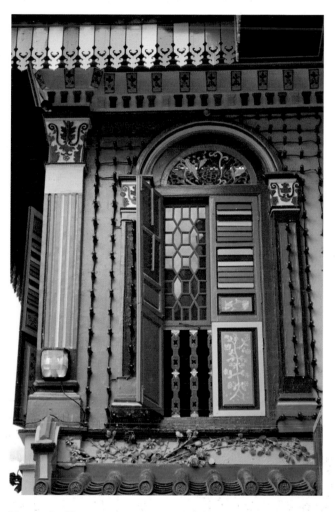

House in Singapore

I love the very defined and bold colors on the façade of this house, something to use in my monoprint windmill painting.

MONOPRINTING BASICS

Monoprinting is a printmaking method. There are endless ways to create monoprints, but in each case, the print can be made only once. Other printmaking techniques can create multiple identical-looking originals. The monoprinting technique using a smooth nonabsorbent surface is one of the easiest to do at home with very few supplies. Monoprints can be wonderful artwork with no additions or alterations, but the prints can also be torn, cut and used as collage elements.

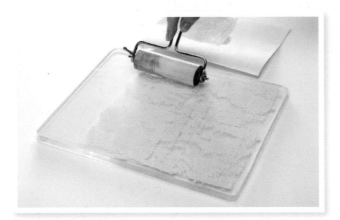

Rolling Out Paint

The surface can be a glass-, acrylic- or gel-plate onto which paint is applied. Acrylic paints work for all three of these. The paint is applied by rolling it out with a rubber brayer directly onto the printing plate. If the paint is heavy and of high viscosity, roll it out on a palette before rolling it onto the printing plate to make sure the brayer surface is evenly covered.

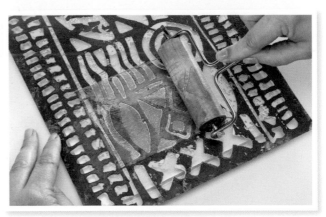

Applying Paint Through a Stencil

The paint on the plate can be manipulated as long as it's wet. This means that images and patterns can be created with additional paint before printing, much like adding paint to a canvas or art journal. This is the **additive method**, which involves rolling paint through a stencil onto the plate to create a pattern.

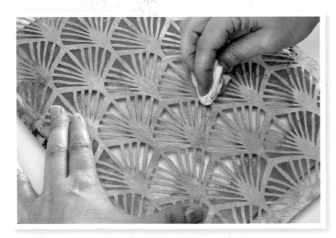

Removing Paint Through a Stencil

Images and patterns can also be created in the still-wet paint using the **subtractive method**, in which paint that was applied to the printing plate gets removed. Put a stencil onto the paint and use a rag or baby wipe to remove paint in the open areas of the stencil. You can then remove the stencil and pull the print.

Tip: These two methods can be combined before the print is made. This kind of multi-step layering works best with transparent or translucent acrylic paints.

Pulling a Print

For best results, work quickly. While the paint on the plate is still wet, carefully place the paper on it. Then transfer the paint to the paper by applying pressure over the back of the entire sheet. Use a baren (a printmaking tool), the bowl of a large spoon, or the palm of your hand to apply pressure. Pull up a corner of the paper and peek to make sure the paint has transferred before removing the entire sheet. Put it back in place and continue smoothing the paper into the paint. When confident that all paint has transferred, pull the print.

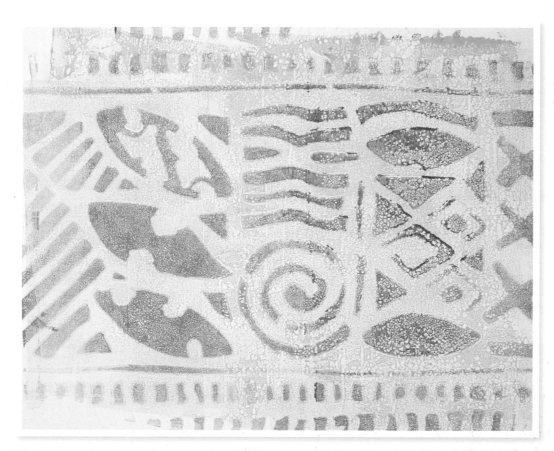

Additive method print

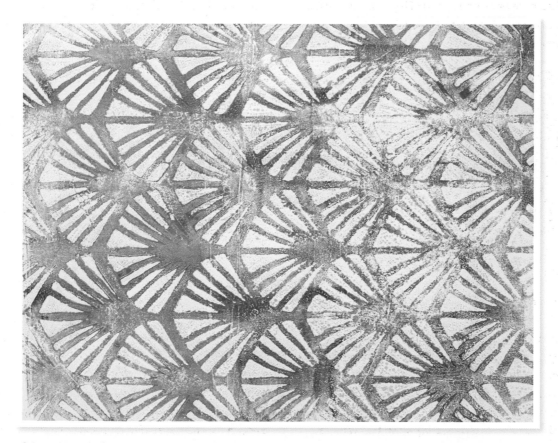

Subtractive method print

MONOPRINT PAINTING

The idea of painting with monoprinting manifested after my friend Birgit and I had visited an exhibition by the Dutch artist H.N. Werkman. Werkman used a printing press, found objects, self-created stencils and stamps to execute very intricate and layered scenes—one section and one color at a time. When Birgit and I came back from the museum, we discussed our impressions of his method and developed our own way of achieving a similar effect by using a monoprinting plate. We call this technique *monoprint painting*.

With practice, the scenes you create with this monoprint painting technique can become more and more detailed and elaborate.

A sheet of monoprint painting

WHAT YOU'LL NEED

- Acrylic paint (soft body or fluid works best)
- Brayer
- Clear transparency (acetate) sheet
- Masking tape
- Monoprinting plate, letter sized (I use a gelatin plate, but you can also use an acrylic plate or glass plate)
- Palette or craft mat
- Palette knife
- Pencil
- Permanent marker
- Rag or baby wipes
- Removable adhesive (optional)
- Scissors or craft knife
- Sheet of copy paper
- Used hotel key card or gift card (small plastic scraper)
- Watercolor paper for printing

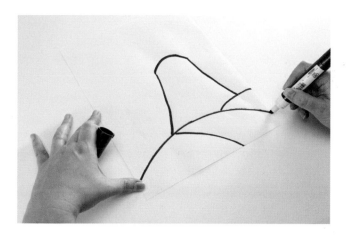

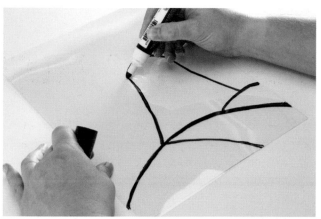

1 Look at your source picture, in this case the windmill photo, and draw a simple silhouette onto a sheet of printing paper. *As shown:* the silhouette of the windmill and the ground lines. I decided to have some hills in front of the windmill to make it more interesting, and I placed the windmill off-center within the space. I did not sketch in the sails, as the lines are so fine. (I will add them later.)

2 Layer the transparency sheet on top of your sketch and trace the outline with a permanent marker.

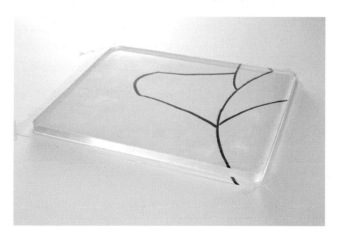

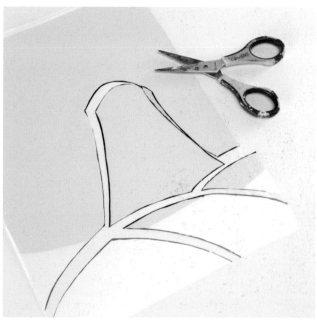

3 Place the paper sketch underneath your printing plate so you can see the sketch through it. *Reminder:* You must leave the plastic backing sheet under your gel printing plate (if using) so the gel plate will not stick to the paper drawing. The plate needs to stay in the same place in relation to the drawing throughout the monoprint painting process.

Tip: Secure the sketch to the work surface with masking tape and align and secure the printing plate on top of the sketch. If the printing plate is larger than the sketch, register it to the left side and the bottom side of your sketch paper and keep this alignment throughout all upcoming steps.

4 Take the acetate sheet and cut it into pieces, one piece per section of the sketch. Use scissors or a craft knife and designated cutting mat. The windmill image results in five different parts: the windmill silhouette, the three hill parts it stands on, and the background.

Tip: Other source photos can be more complicated. If there are many pieces, keep them together and use one at a time so you always know where the sections should be placed. If you get confused, refer back to the drawing beneath the printing plate.

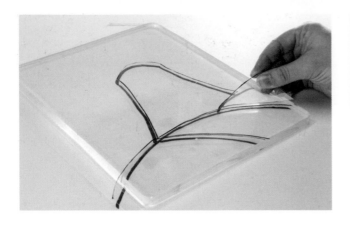

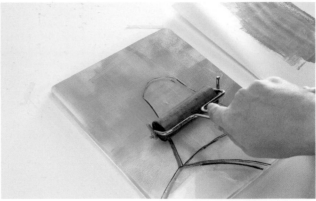

5 Start at the top (the background) and work toward the foreground. In this particular artwork, this happens to be the largest shape and by starting with it, all other shapes are easier to align. Using your reference sketch as a guide, place *all* cutout pieces except for the background on top of the printing plate. These pieces cover and mask the plate and keep paint from getting into those areas.

6 Apply a thin layer of blue acrylic paint with a palette knife, then spread and apply it with a brayer, rolling a thin layer over the printing plate and the masks.

Tip: Make sure to not move masks during the paint application. If using a glass plate, it may be necessary to use removable adhesive to secure masks. If using a gel plate, the acetate sheet usually sticks nicely to the surface and won't move if you are gentle when rolling on the paint.

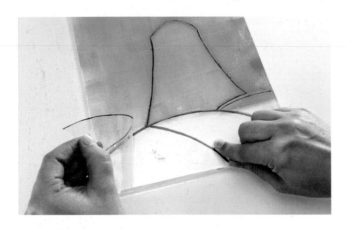

7 Remove the masks.

8 Lay printing paper on top of the printing plate. Align it with the reference sketch for all subsequent steps. Take your hand and smooth over the back of the paper.

9 Pull the print and set aside. Between color applications, clean any leftover paint from the printing plate with a rag and water or a baby wipe.

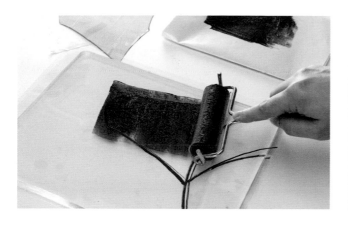

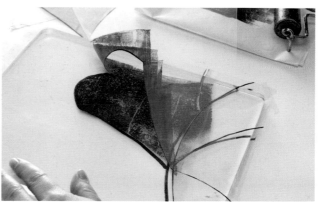

10 Cover up the windmill silhouette, horizon and two of the hill parts. Roll out the next color and brayer it over the masks.

11 Remove the masks.

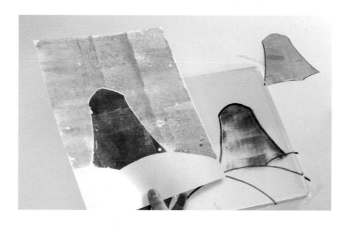

12 Align the printing paper the same way as before. Print.

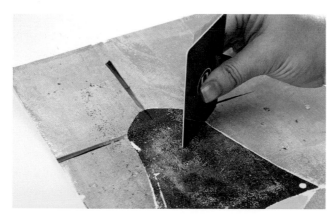

14 The print can be further enhanced by drawing or stamping details on top of it. Dip the side edges of an old key card into paint and use it for making straight lines. Drag the paint to create thicker lines as shown for the windmill's sails.

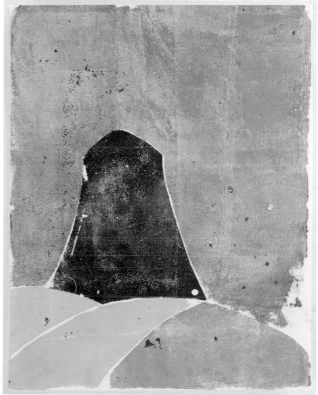

13 Continue with all the remaining parts in the same way until all sections are printed.

Tip: Clean and store the acetate pieces and hold onto the reference sketch. They can be used again and again.

COMPOSITION AND THE FOCAL POINT

The **composition** of a piece refers to where the elements and principles of art come together and how they are organized in the artwork. The composition leads the viewer's eye through the visual plane. Within the composition, the **focal point** calls out for the viewer's attention and emphasizes a specific area of the work.

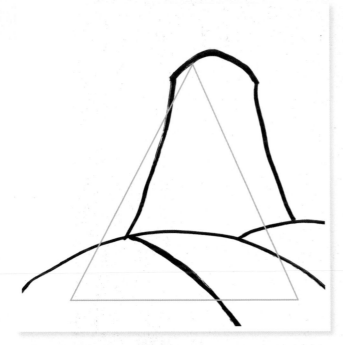

Sketch of triangle with focal points

Placing the focal point in the center of a painting or art journal can make it appear a bit boring (too formal or static). For this reason I changed the position of my windmill in my reference sketch and placed it off-center.

Creating a Focal Point

Contrast can create a focal point if, in a group of similar elements, something is created differently. Contrast can be created using color or texture and can be dramatic or subtle. The focal point always draws the viewer to an intended spot in the artwork.

A dominant figure or shape can create a focal point as well. In my monoprint painting, the windmill is the focal point.

Implied or actual lines can lead to the focal point, directing the eye's movement. Very often artists create a strong and interesting impact by introducing movement between three different focal points, an imaginary triangle, or by placing one focal point within such a triangle.

Placement of the Focal Point

The **rule of thirds** is a guideline that ensures a successful composition. An image is imagined as a grid, divided into nine equal parts created by two equally spaced vertical lines and two equally spaced horizontal lines. When an isolated object is placed along intersecting lines of the imagined grid, it becomes more dynamic and engaging.

Tip: Most digital cameras and smartphones with cameras come with a viewfinder function, which lets you see what you are about to photograph through the grid. If you are trying to decide where to place your focal point or see if it will work, look at your artwork through the grid to get some guidance.

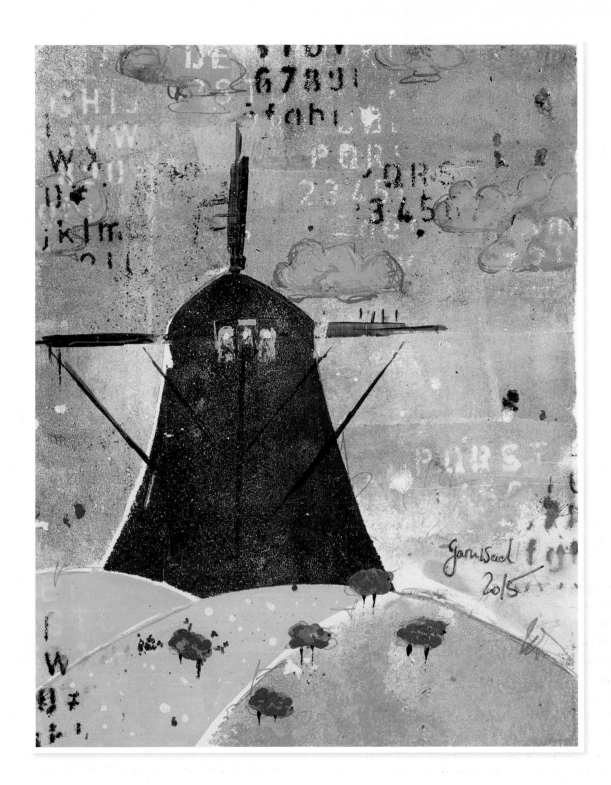

GARNWERD

Nathalie Kalbach
Monoprint with acrylic paint, stamps, spray paint,
and stencils and pencils
11" × 8½" (28cm × 22cm)

Inspired by a windmill in Garnwerd,
Netherlands, using the monoprinting paint
technique in this chapter.

VISITING ART MUSEUMS AND GALLERIES FOR INSPIRATION

Museums collect important works of art and bring them together in one place. Seeing art in this kind of setting challenges and expands the way we think about the world.

THE YEAR OF YES

Nathalie Kalbach
Acrylic paint, ink and pencil on watercolor board
12" × 16" (31cm × 41cm)

Inspired by Jean-Michel Basquiat.

TAKING ART STROLLS

I call wandering through a museum or gallery "taking an art stroll." These visits have become a vital source of food for thought and stimulation for my artwork.

As far back as I can remember, I've loved going to museums. Nothing compares to seeing works of art up close and full scale. Art strolls also allow me to connect with other people, a counterpoint to all of the days spent working alone in my studio.

I try to visit nearby museums at least once a month, taking classes and going to lectures, seeing temporary shows as well as visiting the permanent exhibitions. Museum and gallery visits are high on the list when I travel, too. Looking at artwork and finding what I like and what I don't like about it teaches me a lot about myself. It helps me think more clearly and find pathways in my work.

My art strolls are sometimes solo and sometimes include friends. Artwork experienced with another person can open great dialogues. We discuss how what we have seen relates to our own unique set of experiences. It's interesting to see how and if others connect with the artwork in the same way I do.

When my friend Julie visited me in Germany, we went to the East Side Gallery in Berlin, an open-air gallery featuring a section of the Berlin Wall painted in 1990 by artists from around the world. When the wall came down it was a time of big change for the country, and it was a change with enormous impact across the globe. As women from different cultures, the symbols, colors and words in the paintings triggered very different emotions and thoughts for the two of us. Talking about this experience bonded us in unexpected ways.

I consider myself lucky to live near many major museums and a large number of art galleries. You may not be in that situation, but there are always possibilities for finding artwork on display: smaller galleries, temporary exhibitions shown at a variety of venues (such as community art centers, historical societies, etc.). And when you travel, be sure to seek out museums and galleries.

Taking a closer look at artwork, 2016

Hong Kong Museum of Art, Hong Kong, China

SELF PORTRAIT

Judith Lyster
Oil on canvas
29⅜" × 25⅝" (75cm × 65cm)
National Gallery

I can see in my own artwork the big leaps I make whenever I take the time to translate what I've seen in a gallery or museum. These art strolls lead to experimentation and problem solving. My taste changes and evolves as I learn more about art from different times and places. At one time, I was intrigued most by the Old Masters, but now I find modern and contemporary art far more interesting and in line with my own ideas and aesthetics. I'm able to incorporate ideas from those styles into my personal artwork.

What a wonderful thought: There's something out there in the art world that connects with each of us at this moment in our lives, but as our tastes evolve, it might be different from what touched us in times past or what will inspire us in the future. Best of all, the artwork we see can be a spark—a catalyst for our own work.

Alexey Taranin, *Mauern International (International Walls), East Side Gallery, Berlin, Germany*

NUART

Adam Cvijanovic
Flashe acrylic and latex on Tyvek
180" × 360" (457cm × 914cm)

EXPLORATION WORKSHEET

Learn about the museum or gallery.

Check the website for exhibits, hours, exhibition schedules and ways to reach the location. Find out if you're allowed to take photos and whether a flash is allowed. See if you can sketch, and if so, whether you should do so with dry media only, or if watercolors are approved.

Find out what's in the permanent collection.

Most art museums have permanent collections. Sometimes there are must-see pieces, like the *Mona Lisa* or Picasso's *Guernica*. If time is limited or the museum is large, see whatever is most important to you. Sometimes it's a less well-known collection, but sometimes it's a once-in-a-lifetime visit to Monet's *Water Lilies*, not to be missed! Prepare by doing some research so you know what's in the permanent collection as well as any special exhibits. Plan your visit for about two hours. Take a break if you're going to stay longer so you don't go into visual overload (that zone where your eyes are tired and you feel like your brain doesn't want to take in more information).

Think about what kind of artwork interests you.

Browse among works of art you feel most interested in: paintings, sculptures, drawings or prints. Seek out works done in a particular medium (watercolors, oil paintings, carved marble). Pick a period in history or a category (modern, classical; abstract, portraits, landscapes, still lifes). In other words, narrow it down and don't get overwhelmed.

Take a little art kit with you.

Take a small notebook with you, take notes, make sketches (if allowed) and record the names of paintings or whatever you think you'd like to remember later.

VISIT AN ARTIST'S STUDIO

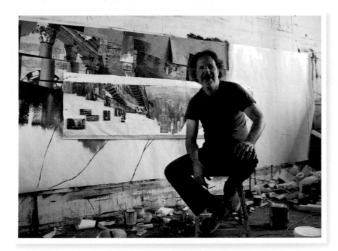

Artist Adam Cvijanovic in his studio in Brooklyn, New York

"I THINK OF MY STUDIO AS A VEGETABLE GARDEN, WHERE THINGS FOLLOW THEIR NATURAL COURSE. THEY GROW, THEY RIPEN. YOU HAVE TO GRAFT. YOU HAVE TO WATER."

—JOAN MIRÓ

Visiting an artist in their studio and getting to know the person behind a piece of art—seeing their tools and their works in progress, talking to them about their process—is a gift that can inspire you in unexpected ways. It fosters connections and provides information.

The artist you visit might be someone you already know, but there are also artists who host open studio time as a way of marketing their work. Others will offer one-day sessions for a fee. Sometimes, cities and towns offer multi-artist events. A good example: Jersey City, New Jersey, where the Art & Studio Tour has been a regular event for twenty-five years. In 2015 it showcased the work of eight hundred artists in two hundred locations. I have participated as an exhibiting artist. I have also visited many studios and purchased art for my home.

A detour into studio visit etiquette:

➤ If you like something, let the artist know. There's nothing more rewarding than instant in-person feedback. Keep highly critical comments to yourself.

➤ Though artists are sometimes willing to share a little bit about their creative process, it's not appropriate to probe too much or start talking about what you would have done differently. An artist's studio is their most precious place. Inviting you into this space is a very special thing.

OBSERVATION

You're now out to look for inspiration in other artwork. Don't be intimidated by a museum or gallery, not even if it's a big, imposing building. Relax, don't rush. Think of a museum or a gallery as an all-you-can-eat art buffet. Pick what you want to see! Go back for more of what you enjoy most, skip what you don't like. But try to be open to everything, including what you might not like right away. Let the museum surprise and delight you. Remember the old saying: Our heads are round so our thinking can change direction.

Things to do:

1. Observe. Find compelling artwork in the museum. What do you like? What feelings do you have? What draws you in? Seek the connection between you and the artwork. Take time to look at things you might not like. Why don't you like it? It's okay to not like something, but try to figure out *why* you don't like it. Do you find the artwork confusing? Do you have positive or negative emotions when looking at the artwork?

2. Change perspective. Take the artwork in from different perspectives. Move farther away, get as close as you're allowed. Resist the urge to touch artwork unless you're visiting an interactive gallery where it's encouraged. How do the brushstrokes look? Can you find and identify the materials that are listed on the signage?

3. Record. If allowed, take photos of the artwork or make sketches. Take photos of signage for research. You can find out more about the artist later.

4. Collect. Buy postcards, take home free brochures, and consider buying a book or exhibition catalog.

5. Relate. The inspiration from artwork can strike in different ways: through the subject matter, the technique the artist used, the colors or shapes, or a similarity to what you like to do in your own work. Being inspired and influenced by the artwork of others is not the same as copying what you see. It's about understanding why an artist's work has been deemed worthy of space in a museum, figuring out what you find compelling, and then implementing those things in your own style, in your own work.

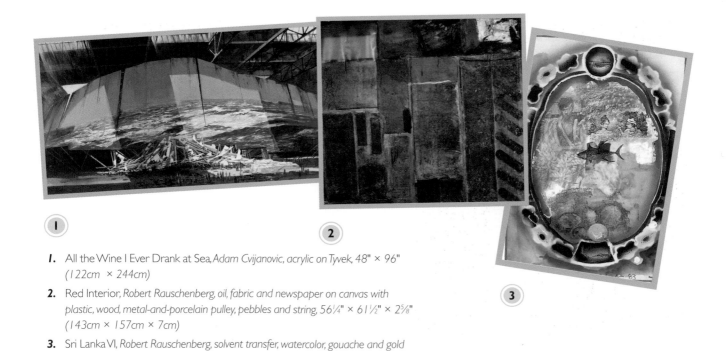

1. All the Wine I Ever Drank at Sea, *Adam Cvijanovic, acrylic on Tyvek, 48" × 96" (122cm × 244cm)*

2. Red Interior, *Robert Rauschenberg, oil, fabric and newspaper on canvas with plastic, wood, metal-and-porcelain pulley, pebbles and string, 56¼" × 61½" × 2⅝" (143cm × 157cm × 7cm)*

3. Sri Lanka VI, *Robert Rauschenberg, solvent transfer, watercolor, gouache and gold leaf on Sri Lankan ceremonial framing mat, 15³⁄₁₆" × 11" (39cm × 28cm)*

REALIZATION

As inspiration for my artwork, I chose a piece by Robert Rauschenberg
in which he used transfers, and a mixed-media canvas by Mark Bradford.
Both artists inspire me, and I seek out their work in museums.

Mark Bradford's Bread and Circuses *appeals to me because of its use of many different layers of papers, posters and ephemera. The layers are collaged and then décollaged over and over again, creating a map-like imagery.*

Robert Rauschenberg's Thai XII *speaks to me because of its imperfect and, therefore, intriguing image transfers and the colorful background. Rauschenberg took the photos used for the transfers on several trips.*

TEXTURE COLLAGE

Here I'm combining the techniques used by Rauschenberg and Bradford for my own artwork, using images taken in Jersey City as well as collected materials.

WHAT YOU'LL NEED

- Acrylic ink
- Acrylic paint
- Bone folder
- Collage material (direct mail, maps, tissue paper, fabric scraps, ribbon, quilt batting, string, etc.)
- Gel medium
- Laser prints of personal photos
- Mask (to protect from fumes)
- Paintbrushes (artist's preference)
- Pencil 4B
- Rag
- Sanding paper or block
- Substrate (I used an 8" × 8" [20cm × 20cm] canvas board)
- Water jars (separate jars for cleaning brushes and clean water)
- White gesso
- Xylene blender pen (I used a Chartpak AD Marker)

Preparation

Think about the topic of your collage and start a collection of things that represent your subject matter. If you've taken photos that represent the topic or that would fit into the collage, print them with a laser printer or have them photocopied as a laser copy. Note that ink-jet printed images will not work for the technique in this chapter. If there is text in the photo, make sure to reverse the photo before printing it so that, when transferred, the text will not be backward.

I gathered tissue paper with lines (representing streets), old checkbook stubs from a Jersey City bank, strings and ribbon, linear elements that can be used for map-like grids, and some quilt batting. I printed my own photos in black and white.

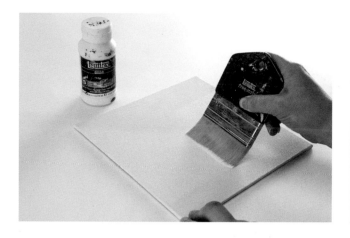

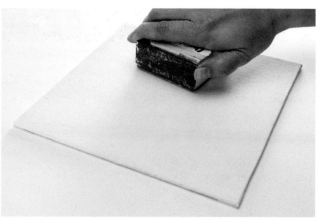

1 For the transfer technique, some areas of the canvas (substrate) need to be less textured and smoothed out. To do this, apply white gesso to the board with a wide brush going in one direction only (left to right, horizontal strokes). Make sure to smooth out the gesso as much as possible. Try not to leave any brush strokes. Let it dry.

2 Sand lightly and use a slightly damp rag to get all excess dust off the smooth section of the canvas. Apply another layer of white gesso, again applying in one direction only (this time top to bottom, vertical strokes) to fill in the rest of the canvas texture. Let it dry and sand it again.

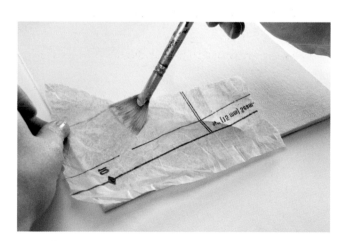

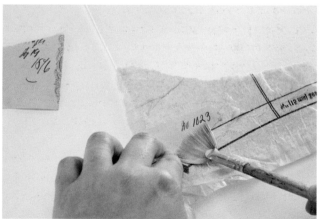

3 Tear some pieces of your thinnest paper material. (I used tissue paper.) Use a brush and a thin layer of gel medium to apply the pieces to the substrate, and another thin layer of gel medium on top of the paper to smooth it out and seal it.

4 Apply all other collected paper materials, working your way up according to thickness and sturdiness. Start overlapping material. Let everything dry thoroughly between layers.

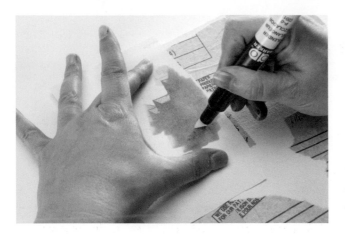 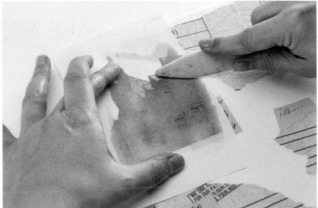

5 Take the laser-copied/printed image and turn it image-side down onto an area of the substrate that does not have too much texture. Using the xylene blender pen, go over the back of the image. The paper will become transparent, and you'll see the image through the paper.

Warning: The blender pen emits strong fumes. *Do not inhale them.* Make sure to work in a well-ventilated area, preferably with an open window. Wear a mask (especially if you work with larger images). Avoid getting the blender solution on your skin.

6 Burnish the image with a bone folder or the side of a brush. Let everything dry for a minute. Lift a small piece of the paper to see if the image transferred. If it has transferred well, lift the paper off. If not, repeat with the blender pen and additional burnishing.

Tip: Image transfers for this project are intentionally imperfect and ghostly. Open yourself up to surprise outcomes.

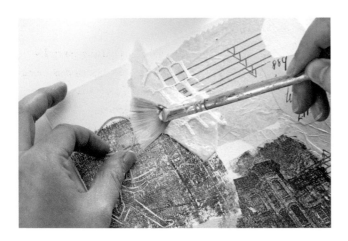

7 Apply the thicker and non-paper materials like fabric, ribbon and string with gel medium. Make sure you don't cover up the areas of the transferred images that you like. Let it dry between layers.

Tip: Thick paper, fabric, ribbon and other heavier materials can be applied more easily if dipped very briefly into water before applying them to the surface with the gel medium. Dampen only; make sure the materials are not wet or drippy.

"A PAIR OF SOCKS IS NO LESS SUITABLE TO MAKE A PAINTING WITH THAN WOOD, NAILS, TURPENTINE, OIL AND FABRIC."

—ROBERT RAUSCHENBERG

COLLAGE AND ASSEMBLAGE

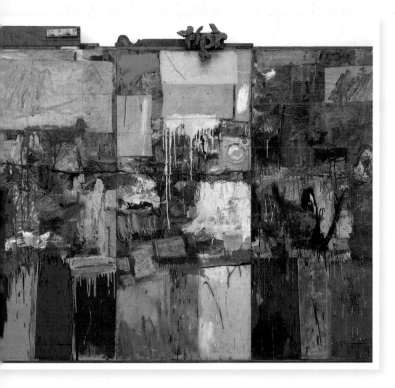

Artists can use collage and assemblage to convey views on social, political and economic issues. The distinction between these two art forms is often subtle and is, sometimes, simply a matter of what the artist calls it.

COLLAGE

Collage describes the technique as well as the resulting artwork in which a variety of assorted pieces of paper, photographs, fabrics and other ephemera are arranged and glued down or otherwise secured onto a substrate. A collage can also include drawing and painting, and is two-dimensional, with elements that are low-relief rather than sculptural.

Since paper was invented, artists have used layered images and added non-fine-art-related materials into their work, but Georges Braque and Picasso made up the term *collage* from the French *to glue/to stick* and turned it into its own art form.

Robert Rauschenberg and Mark Bradford are both known for their collage art. The art pieces *Thai XII* and *Bread and Circuses* in this chapter are great examples of this technique.

ASSEMBLAGE

Assemblage is a three-dimensional collage using everyday manufactured or natural materials (found objects) that were not originally intended as art materials. These elements can and usually do project out from the substrate.

Robert Rauschenberg, Joseph Cornell and Louise Nevelson are some of the best-known assemblage artists, and their work is well worth exploring.

COLLECTION

Robert Rauschenberg
Oil, paper, fabric, newspaper, printed reproductions, wood, metal and mirror on three canvas panels
80" × 96" (203cm × 244cm)
San Francisco Museum of Modern Art
Gift of Harry W. and Mary Margaret Anderson
©Robert Rauschenberg Foundation

Sample of assemblage. Both collage and assemblage artists spend a lot of time collecting materials that can be used to build exciting surfaces and give meaning to their work.

"IF HOME DEPOT DOESN'T HAVE IT, MARK BRADFORD DOESN'T NEED IT."

—MARK BRADFORD

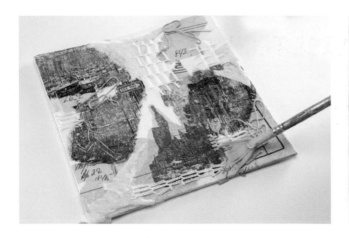

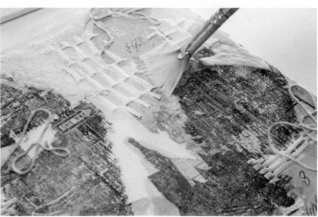

8 Paint on and around some areas of the transferred images with acrylic ink to further enhance them.

9 To unify the surface of the collage, drag a thin coat of gesso over areas that are intended to remain visible, like a whitewash or glaze. Use more gesso if you want to obscure areas or add texture. Avoid the areas with transferred images for this step. (Drag the gesso away from, not over, these areas!) You might pick up some of the still-wet acrylic ink that was at the edges of the transferred images. This is fine; it creates a less isolated effect for the transferred images.

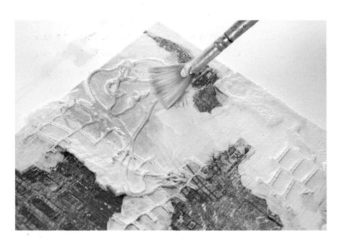

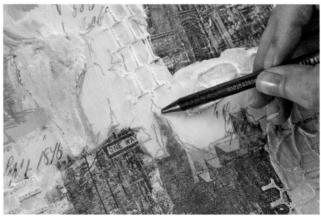

10 Apply a small amount of acrylic paint (I used teal) into the still-wet gesso to tint some of the areas.

11 Use a pencil to add some marks that extend parts of the transferred imagery into the painted surface that surrounds them.

ADDITIONAL COLLAGE TECHNIQUES

Here are some more ideas to enhance your collage. Today's mixed-media artists owe a debt to fine artists who have used these techniques for well over a hundred years. I am especially intrigued by the work of surrealist painters from the 1920s.

SGRAFFITO/GRATTAGE

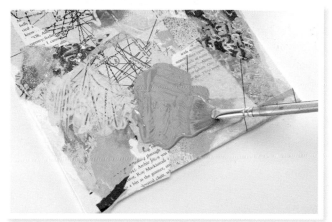

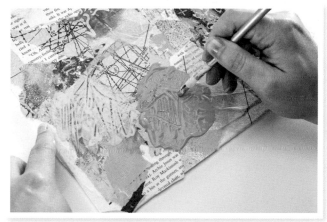

1 Apply a layer of paint over some collaged areas.

2 Before the paint dries, scrape patterns, words or symbols into the still-wet surface using the handle of a brush or a palette knife. This reveals the layer(s) underneath. Let it dry.

GLAZING

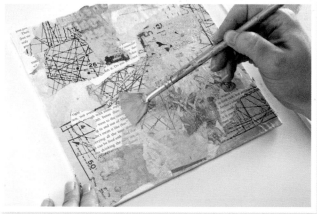

1 Mix one or two drops of acrylic paint into fluid medium to create a glaze.

2 Brush the glaze thinly over the collaged surface. This will tint your surface; it's a great technique for adding depth of color and unifying the surface.

DECALCOMANIA

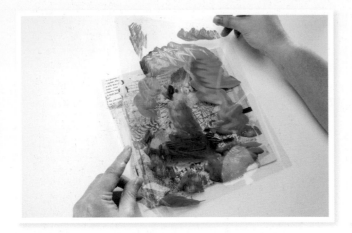

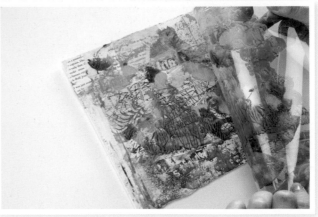

1 Decalcomania is a form of monoprinting. Apply paint to plastic, cloth or paper and, before the paint dries, blot the surface onto your collaged substrate to transfer the wet paint.

2 Lift the transfer sheet off and let the paint dry on your collage.

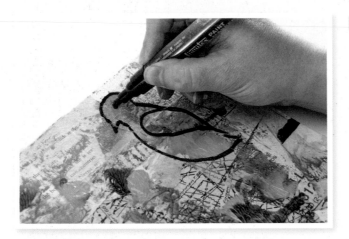

3 Once dried, look for unexpected imagery. Trace around these found shapes with a marker, pencil or more paint.

DECOLLAGE

The word *decollage* derives from French and means *to unstick.* Collage several layers of material. Let it dry. Peel and rip off areas of your collage to reveal former layers.

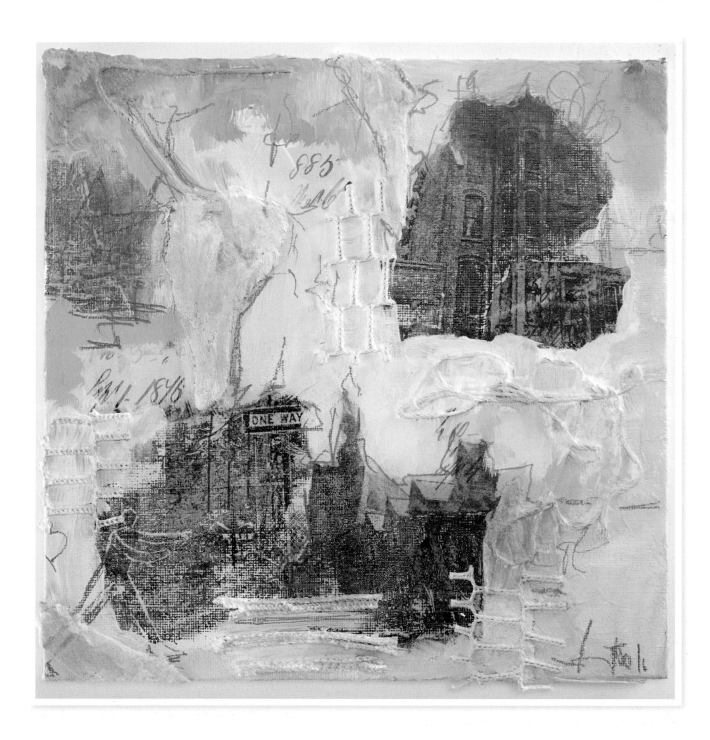

THE GRID

Nathalie Kalbach
String, bedding, paper ephemera with photo
transfer, ink and acrylic paint on canvas board
8" × 8" (20cm × 20cm)

*Inspired by Jersey City street layout and
views using the texture collage techniques
in this chapter.*

6 LETTING BOOKS AND MOVIES SPEAK TO YOU

Books and movies narrate the zeitgeist of an era. Through them, you can put yourself into any given time period— past, present or future.

BROKEN

Nathalie Kalbach
Acrylic paint, media and charcoal on canvas
9" × 12" (23cm × 31cm)

Inspired by the book A Little Life *by Hanya Yanagihara.*

TELLING A STORY

At first glance, books and movies seem to be very different. Books are static type and images, whereas movies are motion pictures. But what binds them is the common thread—they're about stories. They engage our imaginations for an extended period of time, and they can transport us into their narratives. Stories make us reflect on our lives or plunk us into a world that is nothing like our own. I love reading books and watching movies. They evoke emotions and kickstart the storytelling that is part of my artwork.

Next to creating art, reading novels is my most-loved activity. I rarely leave the house without a book—or two, or three. I now travel with an e-reader rather than a heavy stack in my luggage even though I love the smell and feel of paper. I read until late at night, and I've been known to laugh out loud and sometimes cry when a book touches me deeply.

Movies are such a visual feast. Movies about a particular era, captivating characters, a plot that won't let go or thought-provoking subject matter can all be inspiring. I love it when I forget I'm in a movie theater; when I'm so caught up in the story that I jump when something scary happens. When the characters feel like real people, I hold my breath and am relieved when a crisis is resolved. In addition to the plot, the sets, camera angles, makeup and costumes add to the experience. It's easy to see that blockbuster hits influence pop culture. The movie version of *The Great Gatsby* brought the Art Deco period to the forefront of fashion and home décor. The television series *Mad Men* sparked interest in mid-century modern furniture and more.

As in books and movies, narrative can become part of our artwork. In fact, human beings have told stories via art for thousands of years. They told stories by painting images on the walls of caves, carving them onto rocks, incorporating them into ritual and religious objects. Nineteenth-century Dutch artists began painting scenes from daily life, a form of narrative art called genre painting. Today, artists tell stories in multi-panel graphic novels or comic books.

Telling a story in your artwork does not require any particular structure. A lot can be told by using found objects, text and mixed media. I often want to tell a story in my art journals and paintings and do so with color, texture, lines and symbolism, or by depicting a scene that reflects the main element of the story.

With a book haul in Savannah, Georgia, USA, 1994

Reading in Winderswohlde, Germany, after a bicycle tour, 1992

NATURAL SPRINGS

Shepard Fairey
Mural
47' × 147' (6m × 45m)
Jersey City, New Jersey

Newspaper Rock, Utah, USA; a petroglyph panel recording approximately 2,000 years of human's activities. In Navajo, the rock is called Tse Hane, or rock that tells a story.

THE MILLINERS

Edgar Degas
Oil on Canvas
23¼" × 28½" (59cm × 72cm)
The J. Paul Getty Museum

EXPLORATION WORKSHEET

Spend time absorbing the details.

Who made the movie or wrote the book? When and where does the story take place? What is the background of the story? How does it represent a place, an era or a generation? What was going on in the rest of the world at that time?

Identify the story's hook.

What are the surprises? What is the conflict, and how was it resolved? How are the characters developed?

Think about how you relate to the story.

Is the topic something you can relate to? Or can you relate to one of the characters? Have you experienced a crisis similar to the one described in the story? Are there sentences or lines that speak to you?

Research the trends of the time.

If a certain time period is reflected, do some research at a library or via the Internet. What did people wear and how did clothing represent status? What colors were in vogue, what shapes, materials and patterns were used in home décor and furniture?

Study your favorites.

What director, actor, author or genre do you enjoy? Seek out more of what you fancy.

Consider graphic design, advertisement and illustration.

How is the movie advertised? Is the cover of a book what caught your eye and made you pick it up? What aspects of the graphics inspire you, and do you think you can use the color combinations, fonts and other elements in your own work?

Have a notebook ready.

Keep a notebook and pencil handy wherever you read and watch television, such as by the chair in the living room or on your nightstand. You never know when something you hear, see or read might inspire you. Jot it down; don't risk having your thoughts and ideas disappear. If you own the book and feel comfortable doing so, write in the margins, underline or highlight the text.

"IF PEOPLE KNEW HOW HARD I WORKED TO GET MY MASTERY, IT WOULDN'T SEEM SO WONDER-FUL AT ALL."

—MICHELANGELO

ARTISTS IN BOOKS AND MOVIES

LITTLE DANCER AGED FOURTEEN

Edgar Degas
Sculpture, pigmented beeswax, clay, metal
armature, rope, paintbrushes, human hair, silk
and linen, ribbon, cotton faille, bodice, cotton
and silk tutu, linen slippers on wooden base
National Gallery

Inspiration for the novel The Painted Girls *by
Cathy Marie Buchanan*

What better way to get inspired to create artwork than
by watching a movie or reading a book about an artist. It
doesn't have to be a biography or a documentary. A fictional
adaptation can be inspiring as well, and it can help you see
the artist's creations in a different way. Here are some mov-
ies and books about art and artists that I like:

The Way to Paradise **by Mario Vargas Llosa**

This novel portrays the lives of Paul Gauguin and his
grandmother, Flora, and gives insight into their travels and
dreams. This novel is not for the faint of heart and doesn't
offer a flattering portrayal of Gauguin, but it's a great way
to imagine where his inspiration for his vividly colored and
naïve paintings arose.

The Marriage of Opposites **by Alice Hoffman**

This book is a love story, a fictionalized depiction of the
life painter Camille Pissarro's mother. (He has been called
the Father of Impressionism.) Set in the nineteenth cen-
tury on the island of St. Thomas, it provides a unique way
to explore and understand Pissarro's work.

The Painted Girls **by Cathy Marie Buchanan**

This fictional story is about Edgar Degas' model Marie,
who was immortalized in his sculpture *Little Dancer Aged
Fourteen*. It's a behind-the-scenes take on life in Paris in
1878, the time and place when Degas was working on this
famous piece of art.

Frida **directed by Julie Taymor**

This movie is a good starting point for learning about the
life of Frida Kahlo. The colors and costumes are inspiring,
and there are insights into the pain she suffered and how
her life and work were so completely connected.

Jean-Michel Basquiat: The Radiant Child **directed by
Tamra Davis**

This documentary is filled with interviews with Jean-
Michel Basquiat and shows the beginning of his career as
a graffiti artist in the late 1970s. It chronicles his trajec-
tory in the art world where, by the 1980s, he was highly
acclaimed and shown in major galleries.

Exit Through the Gift Shop **directed by Banksy**

This movie by street artist Banksy tells the maybe real,
maybe not real, story of Thierry Guetta and his obsession
with street art. It's thought-provoking and raises many
questions, among them the issue of the value of authentic-
ity in art.

OBSERVATION

Few people want to watch a movie or read a book with the sole intention of trying to find something that could be translated into artwork, yet reading a book and watching a movie can definitely provide a lot of inspiration. Keep the following in mind:

Things to do:

1. **Observe.** How does the book/movie make you feel? What do you agree and/or disagree with? Do you relate to the characters?

2. **Write.** Find quotes within the text or listen for memorable lines.

3. **Look.** Watch for visual stimuli like costumes, colors and patterns and record them in a notebook.

4. **Review.** Use your notes and memories later to prompt ideas.

5. **Pin.** Search for images inspired by the book or movie on Pinterest and create a mood and inspiration board. If you do not like to work on a computer, make an inspiration board for the wall using magazine pages, postcards and more. (A cork bulletin board and pushpins is all you'll need to get started.)

6. **Sketch.** Try to remember visual elements from a movie. Sketch right after the movie if possible.

7. **Reflect.** Close your eyes. What is the first thing that comes to mind if you think about the story in the book or movie? What is the *one* picture or scene that could represent this in your artwork?

1. State of Mind *art journal page. Inspired by a documentary and research for Basquiat's work.*

2. Dreams *art journal page. Inspired by the* Frida *movie set and a quote by Frida Kahlo.*

3. I Love NY, *commissioned by Banksy, painted by Colossal professional painters, New York City, USA, 2008.*

REALIZATION

The book *Alice's Adventures in Wonderland* by Lewis Carroll, illustrated by Sir John Tenniel, inspired my art journal spread at the end of this chapter (page 97). The story is about how Alice is constantly changing while taking on all kinds of challenges. Wonderland is a place where logic is backward, where there are philosophical problems, and riddles abound!

„....it's no use going back to yesterday, because I was a different person then."

Alice's Adventures in Wonderland *by Lewis Carroll, illustrated by Sir John Tenniel.*

This original illustration by Sir John Tenniel is beautiful and well-known. I am inspired not only by the illustration itself, but also by the action of the rabbit: He is announcing something. I will use the illustration of the rabbit in my art journal spread for the technique demonstrated.

Alice's Adventures in Wonderland *by Lewis Carroll, illustrated by Sir John Tenniel. Quote: "...it's no use going back to yesterday, because I was a different person then."*

I am going to use this quote from the book for my journaling. I strongly relate to it because my own personal life story includes so many changes and moves: careers, countries, etc.

ART JOURNALING

An art journal can be described as a visual journal that uses fine art and craft supplies and techniques, as well as journaling and/or ephemera, to tell a story. It is a perfect place to record thoughts or accompany artwork with journaling.

Many fine artists have used art diaries and journals to record their thoughts, to experiment, to sketch and to document their daily life. Frida Kahlo painted and sketched in her diary, making it an art journal. Al Held turned *Life* magazines into visual journals by using oil, inks and printed paper collage on the pages. Leonardo da Vinci's diaries, which were filled with illustrations and writing, are another wonderful example.

Nowadays art journals and visual journals are also popular as an aspect of art therapy, allowing people to process emotionally-charged memories. They're also used for stress reduction.

Ready-made and handmade art journals.

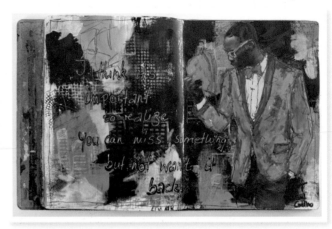

I Don't Want It Back *art journal spread by Nathalie Kalbach using acrylic paint, stamps and stencils, markers and collage materials.*

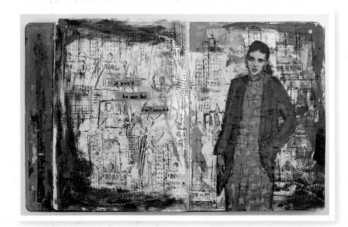

Won't Be Easy *art journal spread by Nathalie Kalbach using acrylic paint, stamps and collage materials, as well as the sgraffito technique discussed in chapter 5.*

Many Beautiful Reasons *art journal spread by Nathalie Kalbach using acrylic paint, stamps and markers, as well as the techniques described in chapter 2.*

I'm In Love art journal spread by Nathalie Kalbach using acrylic paint, ink, stencils and stamps, as well as the glazing technique discussed in chapter 5.

On My Way Home art journal spread by Nathalie Kalbach using acrylic paints, spray paints and markers, as well as a handmade stencil after a photograph of a building as shown in chapter 2.

An art journal can be whatever one chooses. It can contain a lot of writing or just a few words. It can be a diary, a travel journal, a list keeper, an art study book, or an idea repository. There are no set rules.

Here are some tips for art journaling:

- Choose a book with paper that will stand up to wet media and adhesives. If you're binding your own journal, experiment with a variety of surfaces before making the book. Drawing paper that's at least 100-lb. (270gsm) works well. Some people prefer a bit of texture while others like only smooth sheets.

- It's often easier to work on two-page spreads than on individual pages. It can be daunting if the page on the left turns out well and there's a blank page on the right waiting for something new. By the same token, it's not much fun to start a second page next to one that was an utter disaster. Consider whether you want a spiral-bound journal that lies flat but has a coil in the center of a two-page spread, or a bound book that might not lie as flat but has nothing interrupting the center of the space.

- If you use collage material in your art journal, try to keep it as flat as possible. Adding bulky materials can crack the spine of the book.

- Be careful when you use glossy mediums in your art journals. They can make the pages stick together and tear. Art materials will also react to climate conditions. *Tip:* To avoid this problem, precut pieces of wax-coated paper and place them between your pages to prevent sticking. (Deli paper or baker's parchment is best.)

- When layering different paint mediums, make sure to use wax- and oil-based paint products only at the end. Otherwise, they will resist all other art materials and can ruin felt pens and markers.

- Don't like your spread? Keep adding layers. Still don't like it? Paint over it with gesso and see what else might happen.

- Play! You are the boss of your art journal, and it can serve as a wonderful playground to try out new supplies and techniques without the pressure of perfection. Allow yourself to be imperfect in your art journal.

BLOTTED LINE DRAWING

The blotted line technique is a simple printmaking process, one that Andy Warhol perfected in his early illustrations. In this technique, a line drawing on a piece of paper is transferred by blotting it while wet onto a different piece of paper, which results in subtle and stylistically broken lines.

WHAT YOU'LL NEED

- Art journal or other substrate
- Bamboo sketching pen, nib pen or fountain pen
- Deli paper or other translucent, wax-coated paper
- Fan brush (optional)
- Fine brush
- Inks (India ink or acrylic ink) in black and other colors of your choice
- Masking tape
- Pencil
- Source image

Preparation

Find an image in a magazine or book that you want to trace. I printed out a copyright-free image of an illustration by Sir John Tenniel. You can download a PDF of this image at www.artistsnetwork.com/artful-adventures-references-resources.

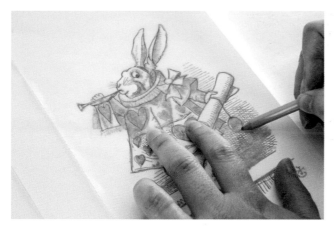

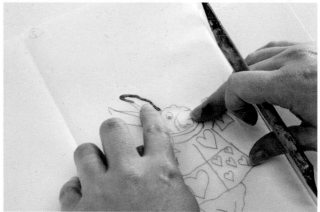

1 Lay deli paper on top of your source image and trace it with a pencil. Trace only what defines the image. Attempting to trace every little line and detail might result in the transfer becoming an unrecognizable ink blob.

Tip: You want the wax-coated side to be face up for the ink transfer later because the ink dries slower on the coated side. Keep in mind that the image will be reversed when transferred. If you want the image to face the same direction as your source image, you need to trace the image onto the unwaxed surface of your deli paper and flip it later. (Or, if you have the ability, you can reverse the image in the computer before printing it.)

2 Flip the deli paper over with the traced image face down and position it where you want the image to appear on your art journal spread. You will see exactly how your image will appear on the page.

Apply the masking tape to the edge of the right side so that half the length sticks to the deli paper and the other half sticks to the art journal. This creates a hinge that serves as a registration tool when you fold the deli paper back again, helping you to position the deli paper in the same spot each time.

3 Dip the bamboo sketching pen into your ink and tap off the excess on the edge of the bottle. This will ensure that you don't have too much ink on the tip of the pen. Start drawing over a tiny section of your traced image.

4 Flip the image over to the journal page and lightly tap the back of the deli paper to transfer the ink lines. *Do not rub* as this will result in smeared ink. Smaller blobs are fine here and there. The lines will not be perfect; this is a transfer process, not a duplication of the traced drawing.

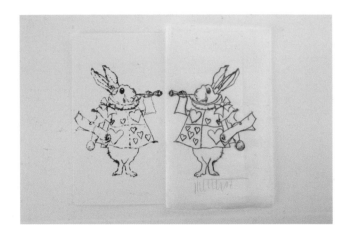

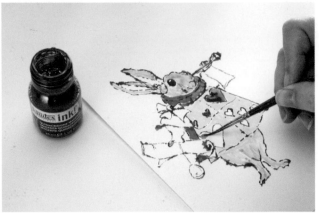

5 Repeat until the entire image is transferred. You can add some details and lines, like the whiskers, directly to the transferred images using the bamboo sketching pen. It's not cheating!

Tip: This is a slow process. Try to avoid rushing. It's tempting to trace large areas of the image, but the results will not be as good as they would be if you worked in small sections.

6 Use a small brush to color in the image with ink. The color will enhance the transferred image even further. Let it dry.

7 Add small puddles of ink to the art journal page, then close the spread to blot and transfer the ink to the other side of the journal spread.

8 Continue doing this until you have transferred the ink you want.

Be careful not to overdo it, and don't use too many colors. Avoid placing wet complementary colors right next to each other so colors don't get muddy. For example, red next to green will end up as brown, and so will orange and purple. (For more information on color, see Colors Are Your Friends and Using the Color Wheel to Pick Colors in chapter 7.) Let the pages dry before closing the journal.

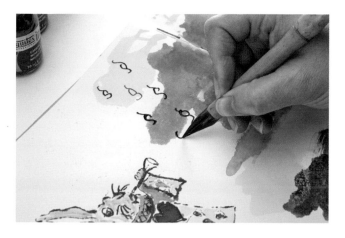

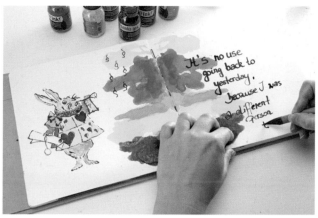

9 Dip the bamboo sketching pen into the ink and add symbols to the page.

10 Add the quote with the bamboo sketching pen.
Optional: Use any pen or marker with permanent ink.

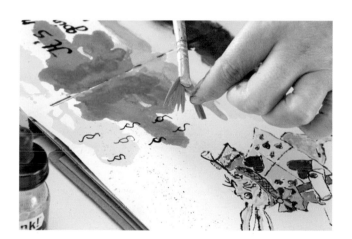

11 *Optional:* Dip a fan brush into the ink. Use your fingers to put some ink drops from the loaded brush onto the page to tie elements together and repeat the colors used.

NARRATIVE AND SYMBOLISM IN VISUAL ART

Artists tell visual stories, bringing deeper meaning to their artwork and communicating with the viewer. Usually, there are two types of storytelling in art—narrative and symbolism—and the two can overlap.

Artists use elements of art such as color and line, as well as composition, gesture, symbolism or a painted environment, to tell a story. They decide what to show and what not to show to give the artwork meaning.

For instance, I was inspired by the symbols in *Alice's Adventures in Wonderland*. For me, the quote I used is about identity. I added paragraph symbols coming out of the rabbit's trumpet like musical notations, representing my former life as a paralegal. The playful inkblots going from the left to the right of the spread symbolize my present life as an artist. Change, identity, looking for answers—the symbols are all in the artwork.

NARRATIVE

Narrative art captures a moment. For example, the dog might run or lie down, trees might blow in the wind or remain still. We see what the artist has shown us, but we also bring our imagination to the narrative.

CAPE COD EVENING

Edward Hopper
Oil on canvas
30" × 40" (76cm × 102cm)

The narrative in this painting includes a couple in the twilight sun in front of their house. The dog is listening to something.

SYMBOLISM

Symbolism refers to images used in the artwork that have meaning to the artist; these symbols depend on personal, historical and cultural experience. The images can be hidden, inviting the viewer to explore his or her own interpretation of the symbols, or they can be obvious, making the viewer understand the intended symbolism. The old masters used to depict religious events with symbolism, and Surrealist artists were known for a broad use of symbolism.

THE ANNUNCIATION

Jan van Eyck
Oil on canvas
36½" × 14½" (93cm × 37cm)
National Gallery

This artwork contains symbolism that refers to the Trinity, the Old and New Testaments and other events. The rainbow-colored wings of the Archangel Gabriel mark immortality and last judgment, and are among several other details significant to interpreting van Eyck's painting.

Art journal spread inspired by Alice's Adventures in Wonderland, *using the blotted line technique in this chapter.*

YAWP *art journal spread, inspired by* Dead Poets Society. *Uses acrylic paints, markers, inks, pencil and wax bars.*

7

OBSERVING PEOPLE FOR INSPIRATION

Our relationships with people affect how we view the world. What they say and do influences our lives, whether it is a loved one, a famous person whose path crosses ours or a total stranger.

WALTER

Nathalie Kalbach
Acrylic on paint, acrylic ink, acrylic marker,
collage and pencil on watercolor board
12" × 16" (31cm × 41cm)

Inspired by my great-uncle Walter and the way he took note of the world around him.

LISTENING, ENGAGING AND UNDERSTANDING

A great deal of my vision for my artwork comes from relationships with people or from knowing about their life experiences. Be they family, friends, strangers or work colleagues, I find their stories fascinating. We are, after all, the sum total of our experiences.

My most inspiring and influential relationship was probably with my great-aunt Margot. She was an exceptionally positive and uplifting person.

In her ninety-four years, she gathered a lot of life experience to share. I have the fondest childhood memories of looking at her huge cache of family photos and listening to her telling me about my heritage, her life and her thoughts. She lived through two world wars and was open about sharing and reflecting upon her thoughts about those times. She and her husband, my great-uncle Hans, loved to travel and went on a lot of hiking tours when they were younger. Unfortunately, Hans was diagnosed with multiple sclerosis in his early thirties, resulting in severe physical immobility. He needed all-day care for a long period of time. When my great-uncle passed away, Margot took his advice to heart and started traveling all over the world, just as he'd wished. She went to Asia, Africa, North and South America and Australia, often with student groups. I loved the numerous postcards she sent and could not wait to hear all of her stories and see the photos she took. The excitement grew as rolls of film were developed and prints were made, and postcards with foreign stamps, which were little works of art at the upper right corner, were delivered long after she had already arrived home.

Many times she told me, "Whenever you have a little bit of time and money, use it. Spend it on travel. The memories of those travels are yours to keep when you are older." It's not advice you usually hear from older family members, who often counsel saving over spending. She followed her own advice, traveling well into her late eighties, and she could recall many details from her adventures even when her short-term memory began to fade. Most of all, she instilled in me the deep belief that you should always remain positive no matter what

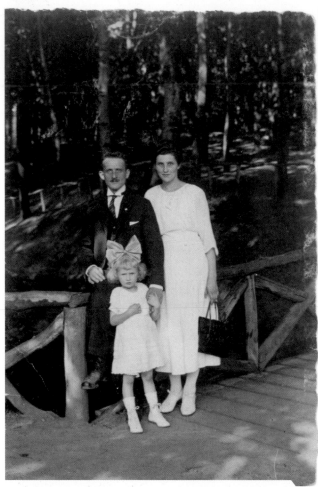

Great-aunt Margot with my great-grandparents, circa 1925

Margot in 2008

Nathalie at law school in Germany

happens in your life. I've created a huge amount of artwork, including collages, altered books, art journal pages and paintings inspired by the life path of my aunt Margot.

During my time as a paralegal, I had to learn to listen to the experiences and thoughts of strangers. Since I worked in an office that dealt with cases involving those seeking political asylum, many of our clients' personal stories were heartbreaking and hard to deal with. It was during my work in the law office that I started my mixed-media journey; it became an outlet to deal with the emotions and thoughts triggered by our clients' lives. Nowadays, as a teaching artist, I meet a wide range of people as students or fellow artists, and our shared love of mixed media and art journaling opens many possibilities for connecting. I've met many awe-inspiring people in the last few years. Each person's story is worth hearing. Listening makes me richer in spirit, and every encounter influences my artwork in some way, however small.

Margot's collection of stamps from different countries in her passports

An altered book dedicated to Aunt Margot

EXPLORATION WORKSHEET

Determine which person you know has the most unique life experience.

What has their life's path been? What sets this person apart from other people you know? Do they have a life story that is uplifting, fulfilling or incredible? Is it something you would like to do? Have they taken a stance on something that is important to you? How did they get to do what they do?

Research their background.

What have those people done or said that inspires you? Do you have overlapping experiences? How do you relate to them? Is their personality similar to or the polar opposite of yours? Are they shy or outgoing, funny or solemn, or does it depend on the situation?

Identify what about them inspires you.

What thoughts or emotions does this person rouse in you? Do they bring up things you haven't yet thought about? Or, does their life or actions prompt an emotion or insight?

Decide if there are life stories that especially interest you.

Who interests you? People who changed careers, did selfless work or were geniuses in their fields? Or simple people whose actions were played out in everyday activities? Whose biography would you most likely want to read?

Think about what you would like to ask.

If you're spending time with a relative and want to ask about their life, think about the questions that most interest you.

THE WHATEVERS

In 2012, my friends Catherine Scanlon, Vicki Chrisman and I founded a creative storytelling project called The Whatevers. The idea was born out of our love of and fascination with photos.

We often find discarded photos at flea markets or in boxes relatives have given us, and we wonder who the people in the photos are, where they came from, how they arrived in this frozen picture frame and what happened to them afterward. Sometimes, there are little traces of history in those photos: the name and the city of a photographer on the back side, clothing that dates the era, or a scribbled note on the side of the photo, but those are scant clues.

My friends and I decided to give those people a story, because as long as they have a name and a story, they are not forgotten. We adopted them into our families and called them the Whatevers. For two years, we picked one photo per month. Each of us would make up a story based on the same photo and incorporate that photo into our artwork. We shared the artwork and the story on the same day and time on our blog, and we posted the photo online for other people to download so they could join in on the project. I created the artwork in a designated Whatevers art journal.

Our characters became a family, and some individuals would intertwine, connect and surface again during our project's duration. It was a wonderful, inspiring and playful way to prompt artwork, and one we may begin again at some point.

You can do the same! Collect some old discarded photos and incorporate them into your artwork; make up stories, quotes and scenes.

Photo with strangers found in a box in my aunt's apartment. What are they saying? What was the conversation before they sat on the canon? Who are they and where were they?

"IT'S NOT WHAT YOU LOOK AT THAT MATTERS, IT'S WHAT YOU SEE."

—HENRY DAVID THOREAU

OBSERVATION

Observing people takes time. We often want to join in a conversation, but if you're willing to step back a bit, you will be amazed at how much the other person opens up, and how much you can actually learn from that person.

Things to do:

1. Listen. Listen more than you talk. If possible, record the conversation. If not, take notes. Pay special attention to nuances, such as facial expressions, tone, what the person spends time describing and what they choose to skim over as they talk about their experiences.

2. Observe. Are there clues in the person's appearance that tell you why you like them? Is it something about their hands, laugh lines, clothing or a piece of jewelry that's like a signature? Does their physical presence express their attitude, sense of humor, stoicism or vitality?

3. Describe. How would you describe your relationship with the person that inspires you? How does this person make you feel? What colors come to your mind when you think of them? Write down a couple of sentences.

4. Photograph. If you're allowed to take photographs of the person, focus on the things you find especially intriguing.

5. Record. Write only if it's not too distracting. See if a word or two can help you recall what you want to remember. Fill in the gaps with notes made as soon after the conversation as possible. I use text from this kind of note-taking in my artwork.

6. Watch. Watch videos about inspiring people. I love to watch *TED Talks* where extraordinary people talk about their experiences.

1. Me, painting a large-scale canvas to create 99 Cent Dream, a painting about gentrification. This artwork was created for a group show curated by Allison Remy Hall and based on her interviews with people in Jersey City and their experiences with the changes in the city. All of the contributing artists created artwork based on those interviews.

2. A huge box with family photos, which I refer to often with my notes when I am looking for something to incorporate into my artwork.

3. My grandmother, my great-aunt Margot and my great-uncle Walter; their life experiences and stories are part of a lot of my artwork. Here in 1948 after the siblings hadn't seen each other for three years.

4. My super creative and supportive husband who sparks many creative ideas in me.

REALIZATION

For my artwork, I chose a photo of my grandmother, Erika, who died long before I was born. My great-aunt Margot, her sister, told me many stories about her, her happy moments and her struggles. I am fortunate to have many photos of her. When I was a child, this photo of my grandmother, taken when she was fifteen, always made me think she was my guardian angel.

For the background I chose a photo I took of a door at La Recoleta Cemetery in Buenos Aires, Argentina. I love the weathered green texture. I am also drawn to the symbolism of doors in general.

My grandmother circa 1928

Weathered green door in Buenos Aires

PHOTO MANIPULATION

Photo manipulation is the process of transforming or altering a photograph by hand or digitally. The techniques shown in this chapter are retouching techniques, which involve using paint media to change photo imagery.

WHAT YOU'LL NEED

- Acrylic inks in colors of your choice
- Acrylic markers in colors of your choice
- Awl
- Background photo printed on letter- or A4-size hemp or watercolor paper
- Black-and-white photo of a person printed on standard photo paper
- Brushes
- Clear gesso
- Corrugated cardboard larger than letter- or A4-size
- Embroidery floss (multi-strand)
- Gel medium
- Journaling pen with permanent black ink
- Metal key (optional)
- Sandpaper
- Tapestry needle
- Water-soluble wax bars in colors of your choice
- White gesso
- Water jar with clean water

1 Use fine sandpaper and lightly go over the background around the person in the picture. This will allow the gesso to adhere better in step 2.

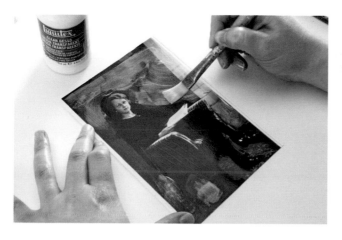

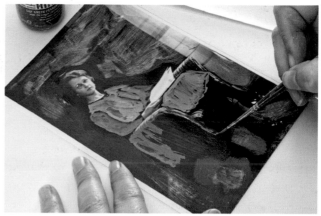

2 Apply clear gesso to the sanded surface to prime it. Let it dry.

Tip: Clear gesso is white when wet but will dry clear. It provides more tooth for the paints and pigments to stick to the surface in the steps that follow.

3 Paint a thin layer of acrylic ink over the non-sanded areas of the photograph. Let it dry.

Tip: Using transparent and translucent inks or watering down opaque inks helps to tint the objects in the photograph and allows the photo itself to shine through, achieving more depth.

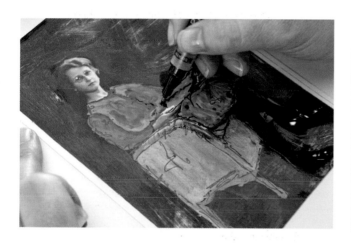

4 Outline some of the tinted areas with a black pen as if sketching.

5 Use one or two similarly colored wax bars in the areas that have been sanded and to which gesso has been applied.

6 Use a wet brush to dissolve the dry wax and blend the colors together. Make sure not to go over the area tinted with the acrylic ink. Let it dry.

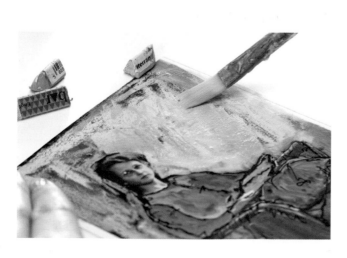

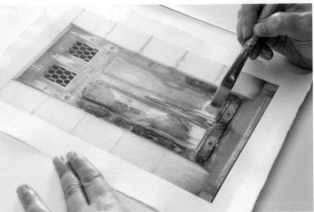

7 *Optional:* Apply some lines and/or symbols with acrylic markers.

Tip: Make sure to use a fluid marker that pumps acrylic into the nib to avoid clogging the nib of the marker.

8 Print a photo that can serve as a background—in my artwork it's the door—on watercolor paper or, like I did here, on hemp paper. Let the print dry. It will already look like a painting on the textured paper.

Use a paintbrush to apply watered-down acrylic ink in colors similar to those in the print.

Tip: To prevent the printer from jamming, make sure the paper is at least 60-lb. (125gsm). It might help to feed the paper into the printer manually by gently pushing the paper through the transportation feed.

9 Add some color with wax bars while the watered-down ink is still wet to create more texture and an even more painterly look on the background. Let it dry.

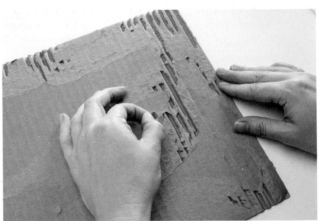

10 Take a piece of corrugated cardboard and pull off some areas on the top layer of paper to reveal the corrugated layer beneath.

"THE CHIEF FUNCTION OF COLOR SHOULD BE TO SERVE EXPRESSION."

—HENRI MATISSE

COLORS ARE YOUR FRIENDS

In my classes I often talk about the impact of color in artwork and use the analogy of colors as friends. By giving each color certain human attributes I create a personal code that I use in my artwork, especially in my art journals. Here are some of my thoughts about colors and how I use them to express certain emotions or convey messages.

In my artwork at the end of this chapter, I used blue and green tones because of the subject matter, my grandmother. My connections with her from the stories told by my great-aunt evoke positive and balanced emotions in me. For the embroidery threads, I chose yellow, brown and gold tones to represent the positive links between me and the grandmother I never met.

Here are some of my thoughts about colors and how I use them to express certain emotions or convey messages.

RED

Red is passionate and polarizing. Red can be a drama queen, the life of a party, or sometimes aggressive. Red wants to push to the foreground. It can't be quiet or in the background for too long. But Red is also warm, passionate and fun to be around! I use Red in small doses for emphasis, to make a bold statement or to express strong emotion.

GREEN

Green is one of my very best friends and most constant partner. It is variable and contradictory at times. Green doesn't like conflicts and can see both sides of a situation. Green stabilizes and revitalizes. I use Green often to express harmony or to create soothing imagery.

BLUE

Blue is an old friend of mine. It's a bit passive, calming and refreshing. It's open to everything but also has authority. Blue easily joins my other friends and is never overpowering. Blue sometimes makes me sad but is a good sport. I don't have to explain things to Blue. Blue is not impulsive and doesn't like to be rushed, as it needs to analyze and think things through. I use Blue to express stability and balance.

ORANGE

Orange is optimistic and extroverted, but not too overpowering. It's stimulating and full of vitality. Orange is more balanced than my friend Red but is also full of energy. I use Orange often, as I feel it makes my other friends sing.

YELLOW

Yellow is a new friend of mine. I am still a bit cautious with Yellow, never sure where it's heading or where it will take my other friends. Yellow is light and positive, and makes me feel good when I'm around it. Yet Yellow is filled with contradictions and juxtapositions. Yellow is always full of new ideas and is my outspoken friend. I use Yellow sparingly in my work to express happiness or simply as a spark of color.

PURPLE

Purple is a one-of-a-kind friend like no other. It is passionate but more reserved than Red. Purple boosts fantasy and is a little eccentric, energetic and charismatic. Purple is a magical, independent, creative friend and brings out the best in others. I use Purple when I want to express something special or bring vitality to my artwork.

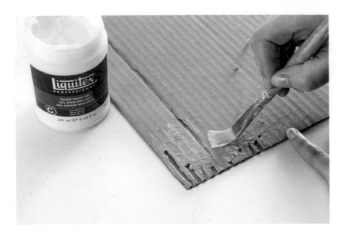

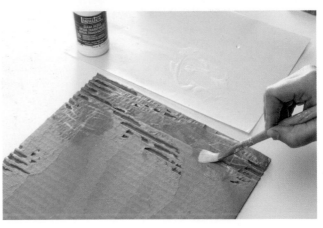

11 Seal the cardboard by painting it with a thin layer of gel medium. Let it dry; repeat, let it dry.

12 Apply some watered-down white gesso over some areas near the edges. Let it dry.

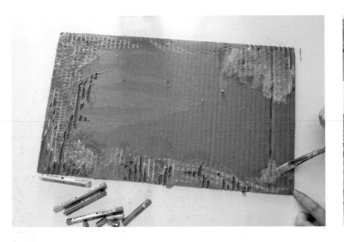

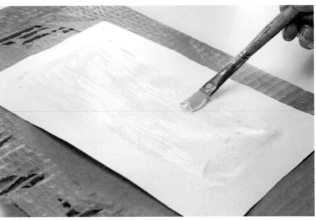

13 Add color along the edges with wax bars. Use the same colors as in the previous steps. Wet the waxed areas and dissolve the paint.

14 Spread a thin layer of gel medium onto the back of the hemp paper, leaving 1" (25mm) toward the edge untouched.

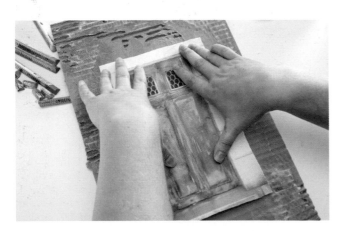

15 Center and attach the paper to the corrugated cardboard.

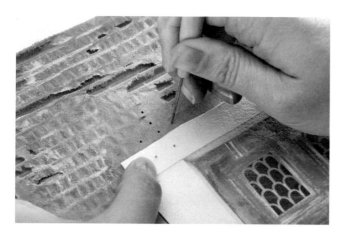

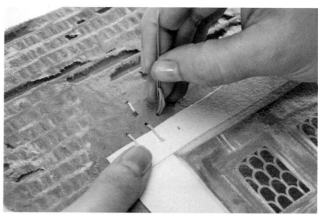

16 To prepare for embroidery: Use an awl to pierce holes where you will be stitching through the hemp paper and corrugated cardboard layers.

Tip: Avoid going through the areas where gel medium was applied; it will gum up the embroidery needle. Clean the awl after use.

17 Stitch through the prepared holes with embroidery floss threaded into a tapestry needle.

Tip: Tapestry needles have blunt points that won't scratch the artwork. That's why the holes for the embroidery were pre-pierced in step 16.

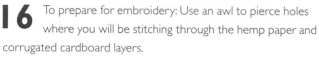

18 Attach the photo of the person with embroidery floss stitching that overlaps the edges of the photos as well as the corrugated board. This will visually tie all elements together.

19 Optional: Add a metal key or other low-relief embellishment using heavy gel medium to secure it to the artwork. Let it dry. Tie the key into the composition by adding some decorative stitching, again using the awl to pierce the holes before using needle and floss.

USING THE COLOR WHEEL TO PICK COLORS

Knowing a bit of color theory is helpful when it's time to emphasize or mute elements in artwork. It can also help to avoid muddy colors when mixing paints.

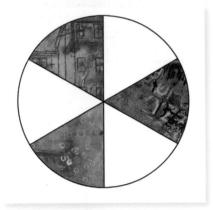

The Color Wheel

Organizing color hues in a circle or a so-called color wheel shows the relationships between primary colors, secondary colors and more. It's a great tool for every artist to explore and deepen their understanding of colors. The color wheel above is a very basic example.

Primary Colors

*Blue, red and yellow are called **primary colors**. Mixing any other colors together cannot create their pure paint pigments, but they themselves can create a wide array of colors.*

Secondary Colors

*The color wheel above shows the **secondary colors**, which are created by mixing two primary colors: blue + yellow = green; blue + red = purple; red + yellow = orange.*

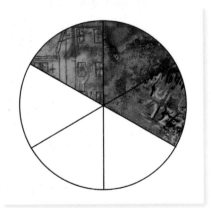

Complementary Colors

*The colors across from of each other on the color wheel are called **complementary colors**. They create a strong contrast when used next to each other and are a perfect way to emphasize something in your artwork or to create a focal point.*

Layered Complementary Colors

When you mix complementary colors with each other, you create brown and gray tones. This can be done intentionally, but it's also important to keep in mind when working with wet-into-wet techniques, monoprinting or whenever a brownish or muddy color is not the desired end result.

Emphasize Three Adjacent Colors

*Any three colors next to each other on the color wheel are called **analogous colors**. They are pleasing to the eye and create harmony in any art palette.*

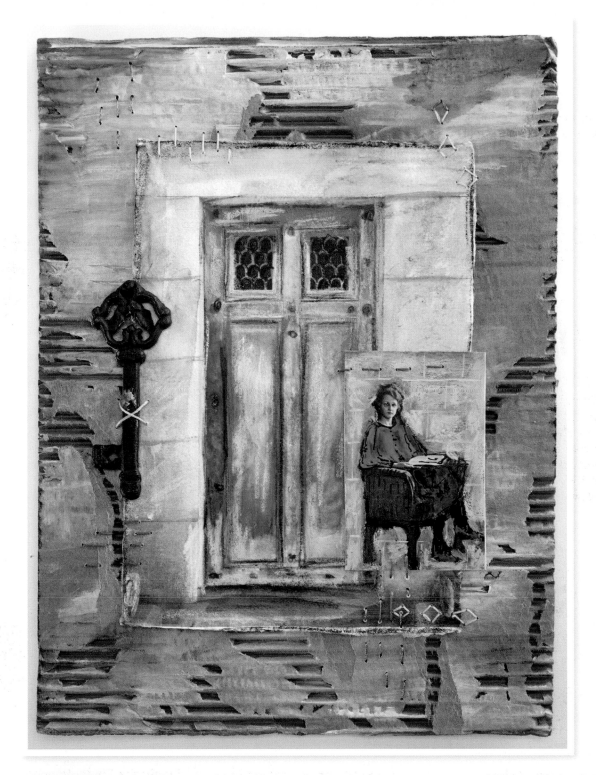

GUARDING ANGEL
Nathalie Kalbach
Cardboard with hemp paper and photo,
gesso, acrylic ink, wax bars, marker,
embroidery thread and metal key
16" × 12" (41cm × 31cm)

*Inspired by my grandmother and family
stories. Uses the photo manipulation
technique in this chapter.*

8

ABSORBING ART MADE BY FRIENDS

Throughout the years, I've been lucky to meet other fellow artists in person and online while teaching mixed-media workshops. Some of the wonderful artists I've met have become friends I've been able to count on in different situations, like in collaborative work, joint museum visits, co-teaching events, discussions or general support of my art and personal life. This group of people is a vital and significant part of my life. They share with me the belief that it makes us better artists when we share and care. Spending time and working together requires mutual respect for the work and views of each person involved. Each time I've opened myself up to other artists, they've unlocked new sparks for ideas in my artwork.

It's important to have a network of like-minded and encouraging friends; that in itself is very motivating. Furthermore, their artwork is a constant inspiration for me. It gives insight into my friends' lives, their subject matter and their interpretations of their surroundings.

I invited ten of my artist friends to contribute artwork based on any of the themes in this book—cities and town centers, traveling, nature, art museums and galleries, literature and movies or people—and asked them to share with you what inspired them, how they translated it and how they suggest turning observations and experiences into artwork.

I hope their artwork and tips inspire you as much as they have me and give you further ideas on how to translate the inspiration around you into your own special mixed-media artwork.

"SURROUND YOURSELF WITH PEOPLE WHO MAKE YOU HUNGRY FOR LIFE, TOUCH YOUR HEART AND NOURISH YOUR SOUL."

—UNKNOWN

TACHELES BERLIN
Nathalie Kalbach
Acrylic paint, acrylic ink, spray paint, marker and stamps on canvas
9" × 12" (23cm × 31cm)

Inspired by Art House Tacheles in Berlin 2006.

NATALYA AIKENS
INSPIRED BY BOOKS AND MOVIES

Natalya Aikens celebrates the beauty of architecture around her and has a love of literature. It is *Anna Karenina*, a novel by Leo Tolstoy, that inspired her artwork.

She sums it up this way: "The novel always felt dark and tragic to me, yet very delicately beautiful. Since my work revolves around architecture, I wanted to imagine what Anna's home was like, and how the home could express all the angst that was in Anna's soul. That's why I worked in Photoshop and with silk chiffon and organza for translucency.

"I think you have to go with the feeling that a book or a movie gives you. Whether it's a happy feeling or a sad feeling, it can be translated through color and texture."

Natalya Aikens's art is architecturally inspired and delicately stitched. The core of it is deeply rooted in her Russian heritage and the architectural imagery of St. Petersburg and New York City, coupled with the use of recycled materials such as paper, plastics and vintage fabrics. View more of Natalya's work at www.artbynatalya.com.

THE PRIVATE HOUSE
Natalya Aikens
Vintage linen, silk organza, silk chiffon, cotton thread
25" × 17" (64cm × 43cm)

SETH APTER
INSPIRED BY TRAVEL

Seth Apter lives and works in New York City. For many years he kept the key that became the focal point of his artwork, waiting to incorporate it into the right project.

"This was definitely the time," he said. "For me, travel is the key that opens the door to so many things: adventure, history, inspiration, excitement, relaxation and much more. This key guided my artistic choices. Given its antique feel, I chose to primarily include other vintage elements, each with a history all its own.

"When I travel, I look for inspiration in anything that is different from what I experience in my daily life. Often after traveling, we get caught up in our daily routine and lose the inspiration we experienced while away. To hold on to these feelings and better be able to express them though your art, bring home small items that you can use to revive your memories."

Seth Apter is a mixed-media artist, instructor and author who lives and works in New York City. He teaches internationally, has published books and workshop videos with North Light Media and is the designer behind his own lines of art stencils, stamps and dyes. View more of Seth's work at www.sethapter.com.

EPHEMERAL DISCOVERIES

Seth Apter
Mixed media on wood panel
10" × 8" (25cm × 21cm)

JULIE FEI-FAN BALZER
INSPIRED BY PEOPLE

Julie Fei-Fan Balzer is a Boston-based mixed-media artist whose work is filled with color, pattern and exuberant energy. She created her piece after a conversation with a friend. Different observations about the same situation demonstrated the dichotomy of how we feel about ourselves and how others perceive us.

Julie said, "I knew that I wanted to create figures of contrasting sizes to visually represent the perception/reality gap. After playing around with some ideas about drawing the figures, I decided to create stencils so that the shapes of the figures would be identical. Inspiration is everywhere. Sometimes it's about not trying too hard. I always tell my students: Follow the shiny ball. Which means follow the idea that is interesting at that moment. Don't stick to the plan. Be like a magpie and follow the shiny ball."

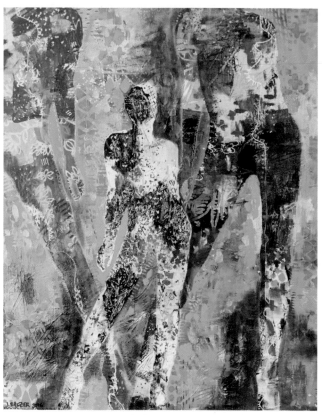

Julie Fei-Fan Balzer is a prolific mixed-media artist. She is the author of the book Carve, Stamp, Play, *hosts the* Adventures in Arting Podcast *and the nationally televised PBS show* Make It Artsy, *blogs five days a week, teaches online and in person, and is a product designer who creates stencils for the Crafter's Workshop, rubber stamps for Impression Obsession and foam stamps for ArtFoamies. View more of Julie's work at balzerdesigns.typepad.com.*

Long Shadow

Julie Fei-Fan Balzer
Acrylic and collage on canvas
16" × 20" (41cm × 51cm)

JUDI KAUFFMAN
INSPIRED BY CITIES

Judi Kauffman was born and raised in Washington, D.C., the city where she found her inspiration among the repeating patterns of the traffic circles, monument columns and tunnel ceilings within the metro (subway) system. A pair of orphaned leather gloves and some rusty metal pieces rescued from a metro platform appear in her artwork.

Judi said, "Because I love making functional objects, especially purses, I decided to create a mixed-media collage on the flap of a felt clutch. I used glue to secure everything because I wanted the finished piece to look as if the elements could be picked up and rearranged. When I use the clutch, I take Washington with me; it's personal and impersonal, harsh and yet welcoming, somewhat gritty but also sparkly and surprising."

Judi has taught for over fifty years, and her advice comes from that wealth of experience: "Make lots of deposits into your own 'visual bank account'! Sketch, take photos, make notes, and sign and date everything. Don't worry about how or when these thoughts and ideas will be used—just keep making those deposits. Make 'withdrawals' as needed. You'll find what you want. Art is the balance between intention, planning and serendipity."

HAND BAG MIXED-MEDIA CLUTCH

Judi Kauffman
Felt, Mylar, leather, metal, elastic
9" × 11" (23cm × 28cm)

Judi Kauffman is a full-time freelance designer, illustrator, writer, teacher and product developer who has worked in the craft industry for over twenty-five years. She has taught graphic design, typography, illustration and studio art at all levels, including long stints at the Corcoran College of the Arts and Design and the George Washington University. Her BFA is in printmaking, and her MFA is in fibers.

BIRGIT KOOPSEN-BERNSTEIN
INSPIRED BY NATURE

Birgit Koopsen-Bernstein is inspired by springtime in the north of the Netherlands where she lives. "The high blue sky, big white clouds, newly plowed landscape and fields filled with colorful tulips and yellow rapeseed are amazing.

"I was inspired by the horizontal lines of the flat country with the colorful fields going all the way to the sea at the horizon, melting together with the pale blue sky. These lines are crossed by vertical lines, like the roads and paths in the countryside, some at angles. It is this mix of linear patterns that provide the underlying grid or skeleton and visual structure unifying my artwork. I am always amazed by the colors of flowers and insects and how, in nature, there are no wrong color combinations," she said.

"Look with great attention to everything around you. Take nothing for granted but ask yourself with everything you see (such as colors, textures, patterns) how you could translate it into your artwork."

Birgit Koopsen-Bernstein is a mixed-media artist, internationally-known art educator and product designer from the Netherlands who loves to work with color and layers and likes to experiment with all kinds of mediums and found materials. View more of Birgit's work at birgitkoopsen.typepad.com.

LENTE OP HET GRONINGER LAND (SPRINGTIME IN GRONINGEN)
Birgit Koopsen-Bernstein
Wool, cotton, beads, twigs and colored baby wipes
10½" × 6" (27cm × 15cm)

MARK LEIBOWITZ
INSPIRED BY PEOPLE

To Mark Leibowitz, art isn't for special moments, and every moment is a "sketchable" opportunity.

"Kremer's in NYC ran a class on how to make your own pigments. Roger Cramora, their ultra-knowledgeable manager, mixed Phthalo Blue and Ultramarine into a unique, thick watercolor blend. I was inspired to record his passion for the science of color," Mark said. Another inspiration: Hieronymous Bosch. "He was such an original. No one painted like him. No one tried to capture the images swimming in his head. His talent was so comprehensive. He created entire worlds in his paintings."

As to offering advice, Mark suggests that you "let inspiration find you as you do your daily artwork. It's often the case that you don't even know how inspired a moment has been until that moment has passed. Inspired art is the residue of daily work."

KREMER'S PIGMENT CLASS
Mark Leibowitz
Rhodia Paper, Uni-ball Micro Vision pen, waterbrush and Kremer Watercolor
8¼" × 11" (21cm × 28cm)

Mark Leibowitz is the founder of New York City Urban Sketchers and the newly-formed New Jersey Urban Sketchers Group and is a drawing instructor at Pratt Institute. Born in Brooklyn, New York, he now lives in New Jersey. Mark has a degree in communications from the City University of New York and a business degree from New York University. Mark is passionate about promoting a love of sketching and encouraging others to explore their creativity. View more of Mark's work at markleibowitz-art.blogspot.com.

JIMMY LESLIE
INSPIRED BY PEOPLE

Jimmy Leslie has always been an artist. Walls in his childhood bedroom and desks at school bore evidence of this fact. His piece, *Lloyd Lives On*, was inspired by and pays homage to Lloyd Halsey, the previous and original owner of his house. Jimmy's studio had been Halsey's two-car garage. The objects that filled the space—hunting, fishing and camping equipment as well as tools and automotive parts—"gave me a sense of his interests as a man," Jimmy said. "Lloyd was obsessive about maintenance around the house. There are still notes by Lloyd written on the basement wall about when the furnace filter was last changed and when it's due to be changed again. The writing that can be made out in the collage is Lloyd's, handwritten on appliance manuals that I recently found tucked away in the rafters."

Jimmy recommends that you "carry a sketchbook with you always! Draw in it, glue things to the pages, write down ideas and don't worry about the outcome. Let it be a visual diary that captures your thoughts and ideas no matter how silly or irrelevant they may seem."

After receiving his MFA from the New York Academy of Art, Jimmy Leslie spent fifteen years as a college art professor until he became the resident artist for Winsor & Newton and Liquitex Artist Materials. In an effort to continually push boundaries and experiment, Jimmy works with diverse modes of expression in oil, acrylic, watercolor, and mixed-media collage. His love of travel, the outdoors and his family are what most inspire and influence his work. View more of Jimmy's work at jimmyleslieart.com.

LLOYD LIVES ON

Jimmy Leslie
Mixed-media acrylic collage on panel
8" × 6" (20cm × 15cm)

RAE MISSIGMAN
INSPIRED BY BOOKS

Rae Missigman has found a real love when it comes to combining paint, textiles and paper. She has a fondness for both pattern and color, which has led her to create outside the lines, resulting in artwork that is both busy and polychromatic.

"My piece was inspired by a book that has rested on our kids' shelves for years. It has been a family favorite for the funny lines and real life meaning behind the childlike color and rhymes," she said. "I was inspired by the endless color and pattern that live within the covers of the book, like eye candy. It led me to want to create my own nonsensical treat, free from rhyme or reason ... filled with marks and brimming with color. Let the emotion that fills you when you embrace everyday things be present in your artwork. Don't let the 'rules' stop you from expressing what moves you to pick up the brush in the first place."

Rae Missigman is a self-taught mixed-media artist who has a passion for repurposing found items and turning them into something beautiful. Her mission—to integrate upcycled tidbits of everyday life into her art—has inspired her to approach creating in a whole new light, sending her on scavenger hunts of the largest kind in search of new materials. View more of Rae's work at rae-missigman.squarespace.com.

NONSENSE

Rae Missigman
Acrylic on canvas panel
7" × 5" (18cm × 13cm)

MARY BETH SHAW
INSPIRED BY MUSEUMS

Mary Beth Shaw loves museums. When she lived in San Francisco, she spent many hours in the San Francisco Museum of Modern Art, and she longs to spend similar time at the Museum of Modern Art in New York City. Her piece, titled *Segmented*, was inspired by work done by Richard Diebenkorn.

"I enjoy the way he divides space, particularly in his Ocean Park series, and I often experiment with division of space in my work," she said, a keen observation, given that Mary Beth designs stencils and, by nature, stencils are based on divisions and segments. "I played with the idea of using a grid and that is how I started. But I wanted to push myself into a somewhat less grid-like space. I chose to use drips as a composition element."

Mary Beth's advice: "Keep a journal of visual inspiration from postcards to magazines to miscellaneous snippets of paper. This sort of discipline will ultimately help you determine where your interests lie and will help in development of color palettes and well as ideas for composition."

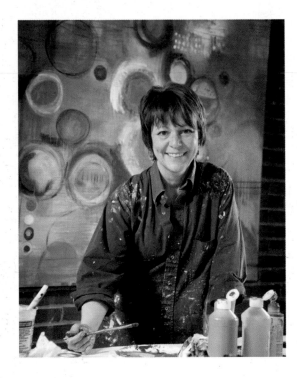

SEGMENTED

Mary Beth Shaw
Acrylic, collage, marker and ink on canvas
20" × 20" (51cm × 51cm)

Mary Beth Shaw worked for five years as a so-called gypsy artist exhibiting at outdoor art fairs and selling as many as three hundred paintings in one very blurry year. She is now a workshop instructor, author and columnist, as well as a certified Golden Artist Educator. She is the founder of StencilGirl Products. View more of Mary Beth's work at www.mbshaw.com.

MICHELLE WARD
INSPIRED BY CITIES

Michelle Ward is inspired by cities and loves to travel. The unique architectural façades and teal waters of the canals in Venice, Italy, inspired her painting. She said, "I wanted to convey the façades of buildings along the Grand Canal in a representative manner, not literally. The collaged layers of windows are photocopies of photos from my own collection. The mooring posts play a significant role in bridging the buildings and the water. I began by selecting a palette that reminds me of visiting Venice. The warm palette represents how the buildings look at sunset, the cool colors represent the unusual water of the canals.

"Besides remarkable landmarks or scenery, I think the most important observation one can take away from visiting a location is the vibe or energy. How the place makes you feel and what kind of memories you are left with can influence the spirit of your work."

Michelle Ward is a mixed-media artist, freelance graphic designer and workshop instructor who enjoys experimenting in different dimensional art forms but always returns to her favorite thing—working with paper and paint in journals. She is a columnist for Somerset Studio magazine; her work can be found in several books. She is a rubber stamp and stencil designer, operating Green Pepper Press from her home studio in New Jersey, where she lives with her husband and their three children. View more of Michelle's work at michelleward.typepad.com.

GRAND CANAL
Michelle Ward
Acrylic paint and gesso on Bristol paper, photocopied photos, stencils, pen
11" × 7" (28cm × 18cm)

Index

a content + ecommerce company

Other fine North Light Books are available from your favorite bookstore, art supply store or online supplier. Visit our website at fwcommunity.com.

21 20 19 18 17 5 4 3 2 1

DISTRIBUTED IN CANADA BY FRASER DIRECT
100 Armstrong Avenue
Georgetown, ON, Canada L7G 5S4
Tel. (905) 877-4411

DISTRIBUTED IN THE U.K. AND EUROPE
BY F&W MEDIA INTERNATIONAL LTD
Pynes Hill Court, Pynes Hill, Rydon Lane, Exeter, EX2 5AZ, UK
Tel: (+44) 1392 797680
E-mail: enquiries@fwmedia.com

ISBN 13: 978-1-4403-4833-4

Edited by Noel Rivera
Designed by Breanna Loebach
Final Design by Jamie DeAnne
Production coordinated by Jennifer Bass
Step photography by Christine Polomsky

Thank you to the Whitney Museum of American Art for permission to use the following artwork:

BREAD AND CIRCUSES
Mark Bradford
Found paper, metal foil, acrylic and string on canvas
134¼" × 253½" (341cm × 644cm)
Whitney Museum of American Art, New York
Purchased with funds from Patrick and Mary Scanlan
© Mark Bradford, courtesy Hauser & Wirth, New York
Photograph by Ron Amstutz

Thank you to the Robert Rauschenberg Foundation for permission to use artwork by Robert Rauschenberg and the National Gallery. Reference for all art pieces used in this book can be found at www.artistsnetwork.com/artful-adventures-references-resources.

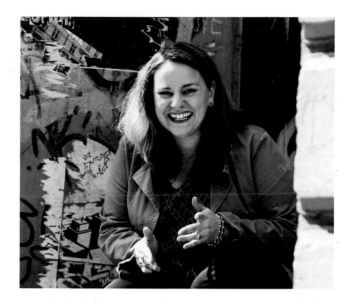

About the Author

Nathalie Kalbach is a self-taught mixed-media artist. She was born in Germany and lived most of her adult life in Hamburg before moving to the United States in September 2013. She now lives in Jersey City, New Jersey.

Her early love of paint was squelched by an art teacher who told her she had no talent. Nathalie worked as a paralegal for seventeen years and might have remained in the wrong profession had she not discovered mixed-media painting in 2004.

Nathalie teaches in-person workshops worldwide as well as online classes. She is a docent and faculty member for mixed media at the Pratt Institute School of Continuing and Professional Studies.

Her artwork is licensed through StencilGirl Products, ArtFoamies, RubberMoon and Stampendous. Nathalie writes about her observations and experiences on her blog: NathaliesStudio.com

Metric Conversion Chart		
To convert	to	multiply by
Inches	Centimeters	2.54
Centimeters	Inches	0.4
Feet	Centimeters	30.5
Centimeters	Feet	0.03
Yards	Meters	0.9
Meters	Yards	1.1

Ideas. Instruction. Inspiration.

Receive FREE downloadable bonus materials when you sign up for our free newsletter at artistsnetwork.com/newsletter_thanks.

Find the latest issues of *Cloth Paper Scissors* on news-stands, or visit artistsnetwork.com.

These and other fine North Light products are available at your favorite art & craft retailer, book-store or online supplier. Visit our websites at artistsnetwork.com and artistsnetwork.tv.

Follow Artist's Network for the latest news, free wallpapers, free demos and chances to win FREE BOOKS!

Visit artistsnetwork.com and get Jen's North Light Picks!

Get free step-by-step demonstrations along with reviews of the latest books, videos and down-loads from Jennifer Lepore, Senior Instructional Designer at North Light Books.